COLUMBIA COLLEGE CHICAGO

3 2711 00119 3873

 W9-DFL-310

SEP 18 2008

Columbia College Library
600 South Michigan
Chicago, IL 60605

WITHDRAWN

魏青吉 作品 | **WEI QINGJI'S WORKS**

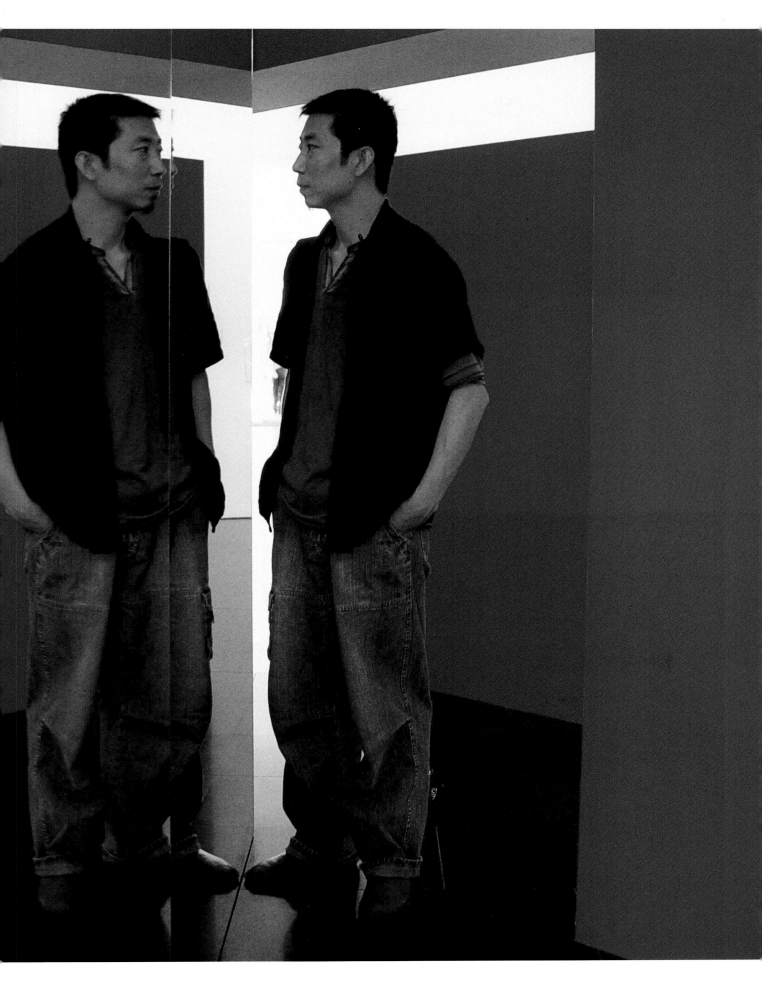

目 录 CONTENTS

我们还能用水墨来做什么？

采访者：郭晓彦

郭：从90年代开始水墨语言的探索开始到如今你的语言风格发生很大变化，你是如何看待这样一种变化的？

魏：90年代中期开始的创作，对我而言，更多的是属于对美术史研究的工作，从美术史的角度探讨水墨媒材在表达上的最大可能性是我那段时间工作的主要方向。长期以来，水墨画在中国一直是一种主观的创作方式，一直是属于表现主义的范畴，没能进入到理性的纯抽象的范畴，对绘画语言抽象化的研究与运用更多的是一种美术史意义上的工作。90年代后期，形式问题已经不是水墨主要的问题，而是要面对具体问题。我的创作显现的是我对历史文脉极大的兴趣，我关注传统和当代之间的那种关系。传统作为精神流动体可以使我们记忆连贯，并告诉我们先人是如何处理同样的生存困境，保证人类在常变常新的同时，仍具可辨识性。我所关心的传统与今天的关系本身尽管是含糊与暧昧的，但也正是其魅力之所在。

郭：可以说，你是在用水墨来做艺术的艺术家里难以归类的那种。一方面，没有把水墨当成一种使命，（在对待民族文化以及它所代表的价值和人文理想的态度、立场），你的作品更多地出现在当代艺术的展览中；另一方面，你还是有很多水墨语言方面的探索，比如，你的语言趣味的问题（格）。你是怎样看呢？你认为水墨（国画）是你思考的出发点还是你创作的一种媒介或者方式？你怎样在你的具体创作中把握自己思考的出发点？

魏：在创作上方式上我保持了一种的惯性——一直用水墨进行创作。因为我觉得它还可以承载自己的观念；并且这其中仍有很多有趣的地方，可以再延伸。当然，我也尝试一些其他的媒介。我的思考是基于当下的文化环境，我并非狭隘的民族主义者，但中国传统文化情结毕竟还是存在的，要讨论属于自身的文化系统的问题，这个问题就很难绕过去。前段时间我在看罗兰·巴特的《符号帝国》，书里谈到为什么东方人（日本人）用筷子，而西方人用刀叉，这是一种民族习惯的传承，里面有文化的沉淀。

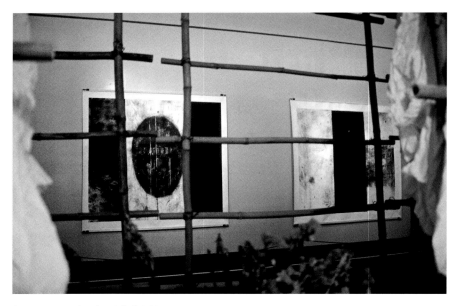

"第一届广州三年展"，广东美术馆，2002
"The First Guangzhou Triennial"，Guangdong Museum of Art，Guangzhou，2002

在中国现在很多艺术家仍坚持用水墨媒材进行创作，这是由于我们和这种文化有一种直接的亲近关系。在艺术创作中，我并没有为了诸如发扬与振兴传统文化等而坚持这样一种媒材的表达，也极力避免使自己落入民俗学的范畴，因而并非刻意将自己融入到中国文化情境中，但平时的思考和阅读刚好在这个场域中，可能自己都不知何时就闯进来了。在意识到这一点以后，我却希望可以将这个问题更明确一点，因为传统和当代的关系越来越重要了，我们所处的时代和文化语境需要这种特质的东西。

在艺术创作的过程中，我也在寻找一种方法论。解决水墨问题长期争论的办法也许应该是创作方法的改变。很多人都用水墨，但一定要有属于自己的概念，否则你的艺术跟前人的没有区别。有人问我，你的画与传统水墨画是什么关系？我很难做明确的表述，但有一种东西无疑是来自传统，那就是我作品中"韵味"的痕迹，这种东西的存在可能比我用水墨这种材料创作本身还要重要，我从不回避我的创作与传统的关系，但这种关系不是图式上的，而是精神上的。

郭：我觉得在你的作品中不一样的地方，正是那种韵味的东西；你的画面是可以进入，是缓慢的，有一种体验的东西，这个东西不是特别急就的，而是慢慢出来的。

魏：是的，这种连贯的东西是可以感觉到的。西方艺术中的张力对我影响很大，没有对西方文化的阅读，我的创作不可能是这样。这种创作肯定与西方当代艺术有关，而且是很顺的走下来的，我的作品一直在讨论这种关系。在图像上（不是指图像意义上的），我的作品的构成方式也不是传统中国式的。图像肯定要变，就像石涛说的，"笔墨当随时代"。因为从事当代艺术的创作就要体现你的"在场"，"在场"就是跟你的生活以及周围的一切发生关系，这种"在场"体现着思考者自己的判断，是思考的过程而不是结果。但其中（作品中）"韵味"是骨子里的东西，是一种本能，他会随着创作的过程慢慢流露出来，并为我的作品带来一种特殊的气质。

我的绘画力图作中性的表达，因为这仅仅是我个人的鉴别，而不是把自己的思考强加给别人；我所提供的是思考提示而不是告诉别人一个判断。艺术创作需要方法论

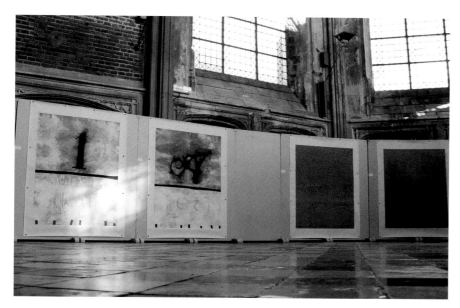

"中国·上墨"，里尔瑞月宫，法国，2005
"Ink on Paper"，Palace Rihour，Lille，French，2005

的转换。我们一直在谈视觉暴力，在图像时代，看得太多，现在，我只想用最简单的方式表达自己的思考，当然这种思考是多意的、双关的、有趣的，别人才愿意读。

郭：你的作品中一直有一种与当代生活对话的愿望或者说努力，在寻找一种方法。你的作品中的场景和日常有一种联系，也有一些图饰是你精心选择的，好象一些具有文化的符号或者具有象征性意义的符号等。但在作品中又有一种故意的陌生感？你是怎样考虑这些问题的？

魏：刚才说到我是作品比较中性、暧昧、模糊。以前的作品《关于系统的构想》、《非情节性叙述》更多地像是一种针对美术史的感性表达，注重绘画语言上的更新和创造；《日常生活的属性系列》、《物——像》系列开始，我想将一种思考的痕迹表现出来，我将日常生活中接触到的图像信息都用于画面。最近的创作接近于"标示符号"，生活中某些标示符号特别简洁明确，不识字的人都可以看懂，我就是想用这种方式，我觉得图像就是让别人一看就能看明白，不要太晦涩，象一种标示符号，做的特别有趣，这是非常生活化的东西，很直接，很单纯。但实际上，在看似简单的图像选择上，有我对日常生活的关注和思考：这些符号是对我们的生活产生过影响的，为什么会有影响，又是怎样地影响我们的思考、对现实的判断和我们对待这些问题的态度其实又隐含在我的作品中，看似熟悉的符号被置换到了另一场景中失去了原本的实用功能，陌生化的情景使我们获得了研究事物的另一角度，看似随意的组合和运用其实是我的考虑的过程，呈现的我的态度和立场。

郭：假如我们把水墨的问题置于一个文化的地位来考虑。看起来是一个艺术取向的问题，实则是艺术价值观和艺术评判标准的差异问题。水墨作为一种东方特质的东西，尴尬的是没有进入一种交流渠道，在关于现代性的讨论中，听到这样一个观点，中国画是不能流通的技艺，是个较为封闭的体系。你如何看待？

魏：正如你说的那样，这的确涉及到艺术的品评标准与体系的问题，以及我们作品的受众到底是谁？对于我自身而言我并非是为了水墨才选择艺术，并且我的作品是

不是水墨也并不重要。我没有想过为国际艺术语境而创作，我只是以自己的方式去面对自己感兴趣的问题，当然这种方式是建立在自己的知识认知之上，建立在阅读之上，这种阅读包括传媒与图像。如果从技术层面来讨论水墨问题，那只是中国美术史的问题，但我想如果从文化的意义上讲水墨也并非完全与当代艺术无关。如果真的有国际性语境存在的话，我想也应该是多元的而非一元。

实际上，这个问题和长期以来的关于艺术的"意义"与"无意义"，中西艺术的"二元对立"等一些讨论相近。近时期以来我们乐于虚拟或假设一些问题，使自己的工作看起来似乎很有针对性，而实际上正是这样一些问题在干扰着艺术家创作取向的判断。我理解你提到的这样一个问题以及东西文化间的差异，但是这种差异并不会造成对作品阅读的绝对障碍。在我看来每一种媒介都有其局限性和开放性，是否局限或是否开放取决于应用这种媒介的艺术家而非媒介本身。对于我的作品而言，我并非是为了所有的人而创作，而是尽量使自己保持在一种边缘的状态——当然这种边缘并非是民俗学意义上的差异。

画油画的人也有做水墨做的好的，他们的出发点不是拓展水墨，而是另外的经验，这种经验是一种补充。我注意到了水墨的异质性，我在思考当代问题时会用另一种经验和方式过滤问题，用一种缓慢一些的方式整理思绪，我曾在一篇文章中提到我的创作立场"不以更新为目的，不以更快为目标。"

郭："时代在握着你的手表达"。所以，艺术一定是与时代有着紧密的联系的。艺术家的思考离不开时代的气氛和时代的问题。怎么看待在当前艺术家的工作？

魏：当前艺术家在时代中位置是提问者，日常性成为艺术的一个部分，而且是很难区分的状态。但艺术家有时候必须站出来反对自己的日常性，有时候又必须跟随自己的直觉，你得有一种独有的特质，这种特质使你的思考是"你自己"的，是独立和经过自己体验的——与众不同。

我想，你要想让我回答的问题是，在当代艺术中，水墨能做什么？其实，用水墨的方式，是我的选择，但这种方式给我很多的异质感，让我在思考问题和对生活提问的时候有一个不一样的角度。这一点是我非常重视的。艺术家就是要在这样的普遍化和平均化的时代提示出特质的东西，提示出被生活埋没的辉晕，提示出看待世界的不一样的思路。

2006 年 9 月 16 日

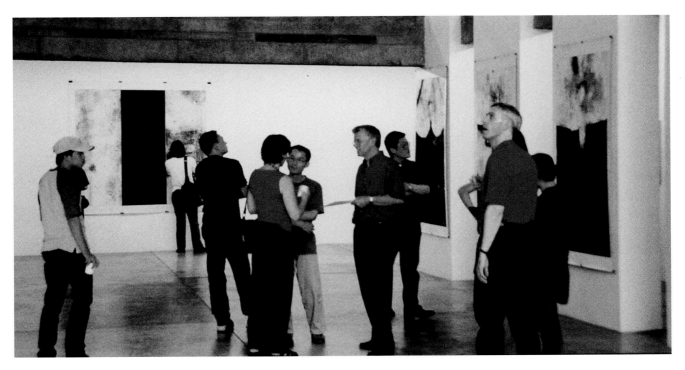

"人类景色"，北京艺术文件仓室，2001
"Human Scenery"，China Art Archieves and Warehouse，Beijing，2001

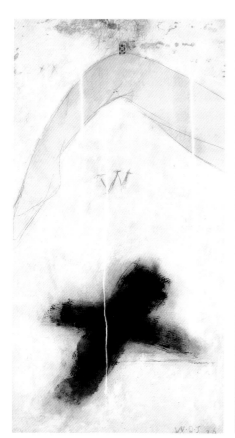 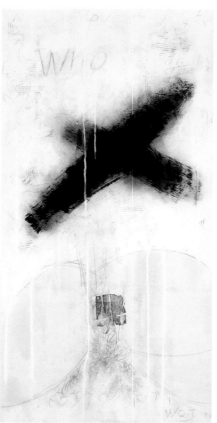 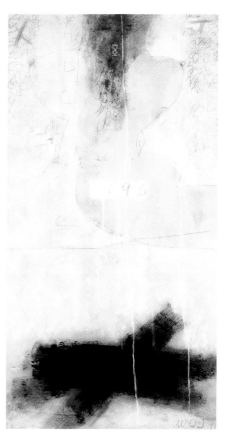

无题（三联）
宣纸　水墨综合
Untitled
Ink and Mixed Media on Rice Paper
136 x 70 cm x 3
1996

WHAT MORE CAN WE DO WITH INK AND WATER?

Interviewer: Guo Xiaoyan

Guo: Your artistic style has been changing a lot since you started the exploration of ink and wash in the 1990s. What do you think about the changes?

Wei: My artistic work that started in the middle of the 1990's was kind of a research on art history, to my point. The main direction of my work in that period was to explore the expressing possibilities of ink and wash in terms of art history. For a long period, Chinese ink and wash has been a subjective way to do art, and has been expressionistic, but has not entered the field of reasonable and completed abstraction. I think the research and application, of the abstraction of painting language, has the meaning of doing research on art history. Since the end of the 1990's, the problem of form has not been my main problem to do ink and wash. My art creation showed great interest in the relationship between the traditional and the contemporary. As a flowing spirit, tradition can connect our memory, and tell us how our ancestors managed to survive in a similar living dilemma, guaranteeing that human beings be recognizable while in an ever-changing situation. Although, the relationship between the traditional and contemporary that I like, much is obscure and ambiguous - that is where the charm lies.

Guo: I feel that it is difficult to classify you into any group among artists who make art with ink and wash. You do not treat making ink and wash as a historical mission (in terms of attitude and standpoint to treat national culture, as well as the value and humanistic ideal it stands for.), since your works appear often in contemporary art exhibitions. While on the other hand, you have made a profound exploration on the language of ink and wash, such as on the tastes of language (style). What do you think of this? Do you think ink and wash is the starting point of your thinking - a media, or a way for you to do art? How do you hold the starting point of your thinking on a specific work?

Wei: According to the creative way, I've been making it a habit to create with ink and wash, since I feel it is available to express my ideas, and I have found a lot of interest in it, and it can be extended in a wider manner. Of course, I have been attempting several other media, too. My consideration is based on the current cultural environment. I am by no means a narrow nationalist, but the complex of traditional Chinese culture stays in me, after all. It is impossible to escape from this problem, if we want to discuss the questions within one's own cultural system. In Roland Barthes's *Empire des Signs*, he said, "The

reason why eastern people (Japanese) use chopsticks while western people use fork and knife to eat, is that it is an inheritance of the national custom, in which there is a sedimentary accretion of culture."

Nowadays, many artists in China persist in using ink and wash as the medium for their artistic creations, and I think that is because there is a direct and close relationship between traditional Chinese culture and us. During my work, I do not work just for developing our traditional culture, and I try to avoid from falling into the field of research on folklore. I do not intentionally put myself into the context of traditional Chinese culture, but recently I am just reading and thinking in this environment; I have entered it unconsciously. When I am aware of this, I seek to make it clearer, because I know that the relationship is more and more important to us, and we are direly in need of things with this character in our time and culture context.

In my working process, I have also been looking for a methodology. I believe that the solution to the dispute about ink and brush should be the change of methodology. Everyone who paints in ink and wash should have his own conception, or he will not be different from his predecessors. Some people ask me what the relationship between my works and traditional Chinese painting is. It is difficult for me to describe it precisely, but surely, there is something from tradition, which I can say is the trace of "lingering charm". The existence of this charm is probably more important than the ink-and-wash material itself. I never evade the relationship between my work and our tradition. However, it is not about graphics, but about spirit.

Guo: What I see, the differences from others in your works are the "lingering charm"; it seems that one can step into the painting, can experience it, and feel that it was not hurriedly painted, but was a slow progress.

Wei: Yes, it is coherent as you can feel. The tension in western art has influenced me a lot. My works would not be like this if I did not have the knowledge of western culture. Therefore, this kind of creation has gradually merged with the western contemporary art, as it appears in my works. In accordance with images, the composition of my paintings is not in a traditional Chinese style. The images definitely have to change, as Shi Tao, one of the most famous artists in ancient China, said, "Art should change with the era." One

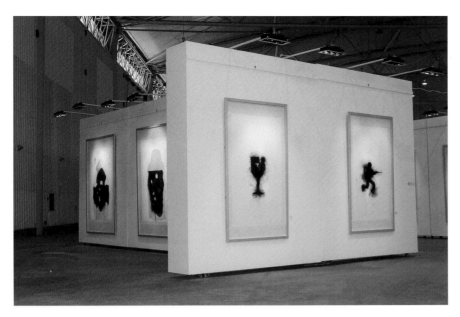

"第二届成都双年展", 成都国际展览中心, 2 0 0 5
"2nd Chengdu Biennale", International Center of Exhibition, Chengdu, China, 2005

thing about contemporary art is to reflect the artist himself, or herself, 'on the scene', which means contemporary artists are connected with their life as well as everything around them. It symbolizes an artists' own judgment and it is the process of thinking, but not the result. Thus, the "lingering charm" in my works is the essence, and you can say it is my instinct to have it. It is slowly revealed along with the painting process, and brings a distinguished temperament into my works.

I have tried to express in a way of describing, because it is merely my own idea, which does not mean to impose my thoughts on others. What I provide is just a question - not a judgment. The artistic creation needs the transformation of methodology. We have been talking about the visual violence that is caused by the many images made in these topical of times. Now, I prefer to express my idea in the simplest way, in which there are multiple meanings and interesting ideas, to catch the audience.

Guo: There is always a sort of wish to have a dialogue with the contemporary life in your works, or say, to seek a method. Almost every image in your paintings relates to daily life, and some of them are chosen carefully, such as some signs with cultural meaning, or with a symbol function. However, it also intentionally provides an unfamiliar sense. How do you consider them?

Wei: Just now, we talked about the character of neutral, ambiguousness and fuzziness in my works. In my earlier works, such as the *Concept about The System*, and, *Narration without a Plot*, I preferred an emotional expression according to art history. I paid a lot of attention to the renewal and creation of painting language; but from the series of *Attribute of Daily life* ,and the series of *Objects—Image*, I started to draw a trace in my thinking, so I used every detail that I saw in my daily life in my painting. In addition, my recent paintings are quite close to "signs". Some signs in our life are so simple and clear that even illiterate people can understand them well. This is what I want to borrow for my painting.

I believe that images should be simple and obvious, but not obscure. They should be like signs, which look interesting, close to daily life, direct and pure. But, as a matter of fact, my choice of these images, that seem simple, shows my concern and consideration about life, which means these images and signs that have influenced our life. My consideration, judgment, and attitude toward reality are hidden in my works. These signs, that seem

familiar, are transplanted into a new context, losing their practical functions. This strange circumstance provides me with a new visual angle to do research. So you can see that the combination and application of images is in the process of my thinking, and they can show my viewpoint and attitude.

Guo: If we consider the question of ink and water in a cultural context, it looks like a question of artistic choice, but actually, it is a question about differences of artistic evaluation and standard of judgment on art. As an art form with the oriental quality, ink and wash has not stepped out in a mass communication way, which is somewhat awkward. I heard somebody say, in some discussions about modernization, that traditional Chinese painting is a closed system, and, it is a technique that cannot circulate today. What is your opinion?

Wei: As you say, this indeed involves the standard of the art evaluation, as well as the identity of the audiences of our works. In regard to myself, I'm by no means choosing art as my career because of ink and wash, and it is not so important that my works are ink and wash. It never occurred to me that I would do my art creation for the international artistic environment. I do what I am interested in my own way. Of course, this should be established from the basics of my knowledge and my reading, which includes media and images. It would be a problem about Chinese art history to discuss ink and wash in a technical manner. However, there will be some connection between ink and wash and contemporary art, if we talk about it in the aspect of culture. Even if we say there is an international context, I think, it should be in a multiple manner but not a unique one.

In fact, this topic is similar to the dispute about if there is some "meaning" in art, or about the opposition between Chinese art and western art. Recently, we have a tendency to hypothesize, or to assume some issues, to make our works a certain aim. But precisely, it is these questions that are bothering artists' judgments on their work, and making them do what is beyond them. I can clearly understand your question and the differences between the east and the west culture. However, the differences will not bring an absolute obstacle for people to understand a work of art. I think every medium has its limits and advantages, and the decisive point is how an artist uses it. Back to my own work, I try to keep myself at the edge area — ensuring this edge is not the difference in the manner of folklore.

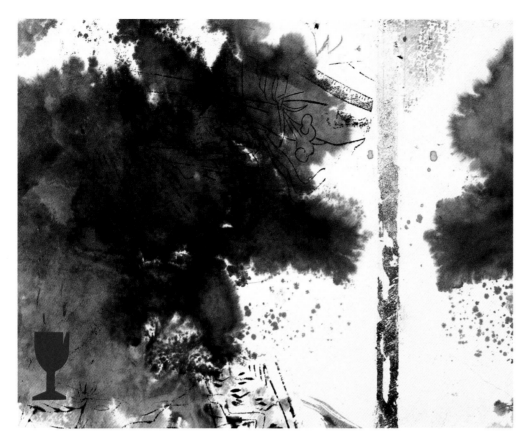

作品 1—C
宣纸　水墨综合
Painting 1—C
Ink and Mixed Media on Rice Paper
21 x 18 cm
2001

Some oil painters can draw ink and wash very well. Their starting point is not just to develop ink and wash, but another experience, a kind of supplement. I have noticed the unique quality of ink and wash, so I will ponder over the contemporary problem through a new way of experience, to sort out my thinking in a slow manner. I once mentioned in an article that my standpoint of creation is "not to renew, nor to be faster".

Guo: "Time is expressing through your hand". Therefore, art certainly should have a close relationship with our age. Artists' consideration cannot exist without the atmosphere and the problems of the present era. How do you regard artists' work at the present time?

Wei: The identity of the current artists at the present time is the question. Our daily life becomes a part of art and it is difficult to distinguish art from life. Sometimes, artists have to stand up and fight against their own day-to-day situation, sometimes they have to follow their intuition, to keep a unique quality, which makes their thoughts their own, and different from others.

I reckon that what you expect me to answer should be what ink and wash is available to do in contemporary time. Actually, to use the ink and wash is my choice, because it has brought to me a sense of unique quality, and made me think dissimilarly. This is what I take seriously. Artists should be capable of finding a unique quality in the generalized and average time, seeking truths hidden in normal life, and posing thought about the world distinguishing it from others.

Sep. 16th, 2006

一种新的水墨观：魏青吉水墨的建构性
皮 力

从第一次看到这个几乎和我同龄的画家的作品的时候，我就喜欢。当时还为他写过一篇评论。但是现在，大约两年以后，当我再次开始为他的作品写点什么的时候，却感到有些犯难。这倒不是因为他的作品不好——相反，我认为这些作品相当出色，而是我似乎无法用现行的各种标准来衡量魏青吉的作品。本来写评论无非是两个目的，一个是为了让别人能看懂他的作品，一个是在看懂的基础上让别人觉得它好。但是，现在如果我们用一大堆水墨界所关心的问题以及由之而产生的标准来看待这些画时，我们却似乎发现在这些作品中找不到年轻的水墨批评家所谓的关于水墨的文化性、批判性之类的标签，或者可以贴上标签的地方。所以我很难让人懂他的作品，或者甚至喜欢他的作品。在此，我试图了解的是我为何喜欢他的作品，当然所有这一切必须是从面对作品开始的。

当代中国水墨的发展或许是所有艺术门类的发展中最让人疑惑的一点。这种疑惑可以从两个层面来表述，首先是美术界对于实验水墨语言的评估存在着根本差异：传统画家认为实验水墨画家的作品没有笔墨或者笔墨的继承性，激进派认为实验水墨缺乏对于现实的直接关注，而实验水墨的支持者认为实验水墨的根本成就在于通过对于传统语言的转换创造出了一种蕴涵着新的文化批判和现实批判的图像。问题的另一个方面在于和其它的艺术门类相比对于水墨艺术所操持的一套批评标准缺乏公共性，这样使得现在的水墨艺术和整个中国当代艺术一样，缺乏来自中国社会内部的支持；而与此同时，水墨作为一种古老东方语汇的这样一种特性，又使得它很难像油画和装置一样，获得来自西方的认同，或者为地缘政治学的拥护者所承认。于是水墨的旁落仿佛成了国际认同或者国际展览机会和商业机会的缺乏的必然结果。

就像我在前面说到的那样，如果按照这两种思路谈下来，我们可以谈到文化或者现实批判，或者文化霸权主义，甚至东方性、书写性、观念等一系列无休又无止的问题。问题是，如果没有这些问题，水墨是否还有存在的必要或者现实针对性呢？或者我们可以换一个方法追问，水墨的创作是否必须要反映现实或者与之联络在一起才有可能具有某些意义呢？我想这个问题可以在魏青吉的作品中找到答案。

因为魏青吉的水墨语言让我们无法轻易定性。在他的作品中，所有的语言都是暧昧的，如他试图述说的东西。可以说，在他的作品中有两个特点，一个是语言特性的暧昧，一个是图像的个性化转接。对于很多有美术史图像背景的人来说，在这些水墨中存在着太多西方艺术语言的图像背景。但是这不应该成为我们无视这样一个富有才华的年轻画家的理由。在新一代的画家心中，使用一种语言并不意味着对于这种语言所代表的文化的认同，他或许甚至会认为，在今天文化和语言之间根本不存在某种一一对应的关系。水墨不等于东方精神，油画不等于西方文化。如果说现代主义运动是发明出了一种又一种语言并保存起来，贴上标签，那么在今天则是要撕下这些标签，将语言拿出来揉合在一起。语词的更新是缓慢的，年轻的生命或许等不及，但是他之所以年轻在于他能用陈旧的语调发出新的声音。

新一代画家没有老画家那种完备或者半完备的水墨氛围，他们对于水墨的依恋也是有限的。相反，他们似乎是在西方图式语言的浸润中成长起来的。前代画家是自觉地将水墨的现代化看做一个中西结合的过程，甚至是一个通过中西结合最终东方精神取胜的过程。但是现在所有的艺术家都知道，一种风格的成功不是作品本身就可以达到的，而是这种风格在各种动力的作用下，在画家、画廊、博物馆的三角形上滑动的结果，对于水墨来说这种滑动还有两种意识形态较量的作用，所以更加复杂。我喜欢魏青吉的作品首要原因是他对于语言的"无所谓"态度，这种无所谓意味着和以前的画家不同：不是试图通过用语言的转换来进行东西方的文化之战，而是利用作为年轻的中国水墨艺术家本身的身份的特殊性，将这个过程转换到一个自然的潜意识层面。

他的可贵之处在于一方面继承了本土前几代水墨画家探索的语言成果，但是同时又没有在东方精神上孤注一掷。他从不在画面中回避西方语言图式，但是这些图像确实被无意识的改造过，这样，以传统用墨方法的墨在画面中产生了新的意义空间。流动的白色，成为图式的阻隔机制，也成为墨的负空间。它们既和夸大的墨色的力度形成张力，又在画面上制造着新的空间。白色在此不是作为颜色出现的，而是作为

"魏青吉个展"，马赛第三大学，法国，2006
"Wei Qingji Solo Exbihition", Marseille III University, French, 2006

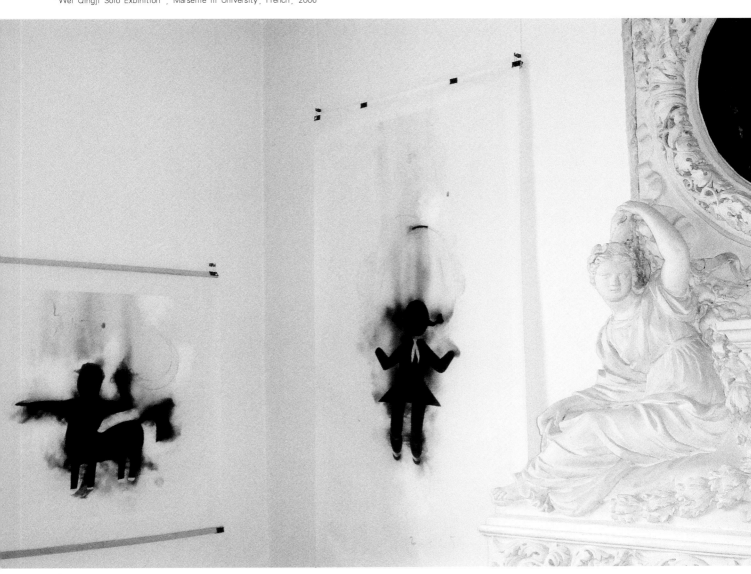

"虚幻"博物馆63，香港，2003
"Illusion"，Museum 63，Hongkong，2003

意义空间的塑形机制出现。它们的出现加深了画面的空间，而这种空间的达成不是像西方现代绘画那样通过潜在的透视来实现的，相反它们是出自传统水墨中"留白"的语言逻辑。与此同时，画家加大了作品的媒介范围，使用铅笔、茶水、喷漆、金粉、锡箔等，不断加强着空间的层次。魏青吉充分发挥了传统水墨中丰富的墨色的表现方法，将不同的墨色和不同的形状结合起来，通过色色、色形和形形之间的不断对比使画面具有一种叙事性，使作品从当代水墨抽象性的窠臼中脱离出来。

魏青吉的作品满怀着沟通的渴望。它们所表现的是现实体验的某个瞬间，某种无法诉诸语言的情愫。在这些充满知觉体验的画面中，有时是一种迷幻的宗教感，有时是一种奇特的图像的转接。所有的这些私密性的情绪体验，都被画家用丰富的语言表达出来。如果说在这些画面中有一种什么东西刺激着画家的创造和思考的话，那么毫无疑问是图像。可以说图像的转接是这些情绪化意象出现的核心力量。年轻的画家用各种符号和各种手法一点一点地小心堆积。无论是自然世界中的花草，还是语言世界中的一个音符都是他使用的对象。他仿佛具有一种神奇的魔力，能将自然图像、语词和艺术图式之间的关系打通并巧妙地转接。所有的这些，都是他作为一个现代画家在现代社会中微妙体验的外化，而这种微妙体验又是和语言的暧昧性相暗合的。

魏青吉的艺术语言的推进是和现实体验的表达紧密地结合在一起的。从他的作品中我们甚至看到现实体验的表达往往还是处在一个重要的位置。更为可贵的是，魏青吉的作品没有被某些浅见的批评家所误导，生硬地给自己规定一个关注现实的命题，堆砌出一大堆现实的图像；他其实是怀着前所未有的热望、关注着心灵的现实，关注着现代社会对于心灵的种种作用。在他的作品中我看到了一种少见的轻松状态，他自由地在各种符号、各种手法中遨游，将自己的作品作为记录手段，记录着自己在遨游中的点滴感受。水墨的使命感、水墨的认同、水墨的现实性都被这种遨游中的感受所覆盖。他所做的不过是正视自己的存在，正视自己身份的差异性，将这种差异性以叙述的方式表现在画面中。其实问题没有那么复杂，选择了水墨就是选择一个

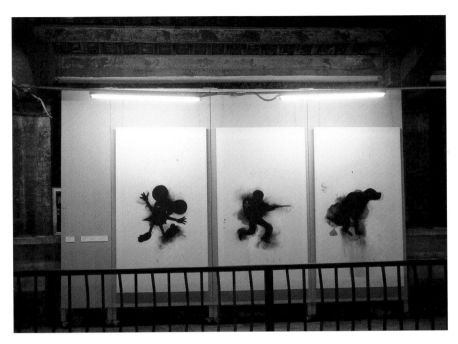

"第二届广州三年展"广州信义国际会馆，2005
"The Second Guangzhou Triennial"，Xinyi International Club，Guangzhou，2005

他认为有无限希望的语言，表达就是表达自己的现实感受，而不是语言的附加值。我是东方人，我的作品自然会有东方性；我是现代人，我的作品自然会有现代性；我是思考的，我的作品自然会有观念性；我是渴望表达的，我的作品自然会有沟通的可能性。

对于魏青吉是如此，而对于我来说这种无所谓的态度实际上还蕴涵着一种建构。在新一代的水墨画家中，那种批判性已经消散，他们在某种程度上说不再是忿忿不平地说"不"，而是冷静地在探索着"我们可能、可以做些什么"。因此、魏青吉作品的意义不光在于画面本身的意味，而在于他那种轻松的态度揭示出了一种新的态度，暗示着一种新的可能性；他用他的实践告诉我们，重要的不是"水墨是什么"、而是"我们能用水墨来做些什么"。

1999年4月于北京

原载：《黑白史·中国当代实验水墨1992—1999·魏青吉》湖北美术出版社，1999年。

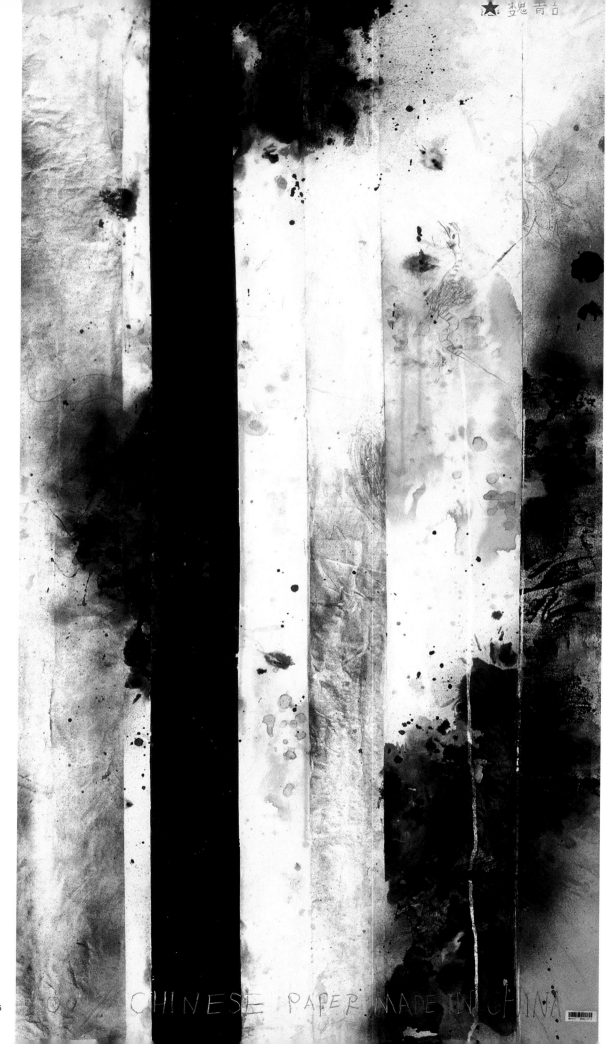

记忆的属性No.1
宣纸　水墨综合
The Property of Memory No.1
Ink and Mixed Media on Rice Paper
180 x 195 cm
1999

A NEW VIEWPOINT OF INK AND WASH

Pi Li

I liked the works of Wei Qingji, an artist nearly my age, from the first time I saw them. I even wrote a criticism essay about Wei's works at that time.Now, after about two years, when I want to write something about his works again, I find it really a tough job. It is not because his works are not good enough - on the contrary, I think they are excellent. I just cannot judge them by any standard currently in effect. In fact, writing a criticism has only two goals: one is to let people understand an artist's works; the other is to let people appreciate them based on understanding.

If we look at these paintings with the problems that ink and wash circle concerns, and the standards they produce, it seems that we cannot find any cultural or critical labels those young critics talk about, or any place where labels can be stuck. So it's hard for me to make people understand, or even like his works. Here I would like to understand why I love his works; of course, all should begin by facing the works.

Maybe the development of Chinese wash painting in the present age is the most puzzling thing in all of the art forms. It can be explained on two levels. First, art circle's assessments, on the artistic language of experimental wash painting, are highly varied: traditional artists hold that the works of experimental wash painting artists are not wash painting at all, or do not have any inherent nature of it.

The radicals think that such kinds of art has a lack of direct attention to reality. However, the supporters of experimental wash painting believe that its basic achievement is that it has been creating images containing new cultural and realistic criticism through transformation of traditional artistic language. The other side of the coin is that, compared with other art forms, the whole set of critical standards of wash painting art lacks in common sense, which leads to a shortage of support from the Chinese society, such as other forms of contemporary art in China. Meanwhile, for the sake of its character, as an oriental artistic language, it is hard to gain recognition from the West, or the supporters of geopolitics, like oil paintings, or installations. Thus, the inevitable result of experimental wash painting is lacking in international recognition, or exhibition and commercial opportunities.

Just as I have mentioned above, if we follow the two trains of thought, things which should be further discussed would be: cultural or realistic criticism, cultural hegemonies, and even Orientalism, nature of writing, ideas and other endless problems. Nevertheless, the

"墨和纸－中国当代艺术展" 德国魏玛美术馆，2005
"Ink and Paper—Exhibition of Contemporary Chinese Art", Kunsthall Weimar, Germany, 2005

point is, without these questions, whether wash painting still has the necessity of existence, or still can keep the reality in mind. I think we can look at this from another perspective: does ink and wash have to reflect, or link, with reality to gain its meaning?

The key to the question is hidden in Wei Qingji's works, because it is hard to determine the nature of his painting language. In his works, the artistic language is ambiguous, just like the things he tries to describe. There are two characteristics in his works: one is the ambiguity of artistic language, the other is individualistic transformation of images. Those familiar with Chinese art history would think too much background of western artistic language images can be found in his works. But, it shouldn't be a reason for us to neglect such a talented young artist.

For the new emerging artists, using an artistic language does not mean recognition of the culture it stands for. Furthermore, they may think that there is no direct one-to-one relationship between the culture and artistic languages these days. Wash painting is not equal to oriental spirit, and it is the same case with oil painting in western culture.

If we regard modernization as invention, preservation and labeling of languages, then today's task is to tear off all the labels and to mingle languages. The updating of words is too slow for the new artists to wait, the new artists are young, and they have the ability to make obsolete words to pronounce new sounds. Young painters do not have the perfect, or semi-perfect, atmosphere of wash painting, as the older generation does, and their attachment to it is limited. On the contrary, it seems that they are growing up with an infiltration of western image languages.

Previous artists consciously regarded the modernization of wash painting as the combination of the East and the West, and even the success of Eastern spirit. However, nowadays all the artists know that the success of a style is not gained through the works themselves, but through various motive force effects, and is the result of sliding on the triangle of artists, galleries and museums. With regard to ink and wash itself, the slide is also affected by the struggle of two ideologies, so it becomes even more complicated.

The essential reason that I like Wei's works is the "arbitrary" attitude he holds towards artistic languages, which shows his difference with previous painters. Not trying to stir up a cultural war between the West and the East, Wei makes use of the special status of being

"无常"，香港艺术公社展，2003
"Uncertainty"，Artist Commune，Hongkong，2003

a young Chinese artist, and shifts this process to a natural subconscious level. He is to be commended for that. On one side, he has inherited the achievements in artistic languages the previous ink and wash painters explored; meanwhile, he does not stake all on a single throw of oriental spirit. He never avoids western artistic language and images, which have surely been remolded unconsciously. Thus, the ink painted through traditional skills creates a new sense of space in the picture. The flowing white becomes the separating mechanism as well as the ink's negative space. It not only forms tension between itself, and exaggerating dynamics of ink, but also creates new space in the picture. White, not emerging as a color here, but being regarded as the molding system of sense space. Its appearance deepens the picture's space, but this is not realized by potential perspective like western modern painting; on the contrary, it originates from the linguistic logic of "remaining blank" in traditional wash painting.

At the same time, Wei has been broadening the media of his works through using pencils, tea water, spray paint and golden powder, etc., in a way that he has been increasing the levels of space. Wei gives full play to the abundant expressing methods of ink in traditional ink and wash, combining different ink colors with different patterns to make the picture a kind of narrating nature through constant comparison between colors and patterns, which does separate his works from the set pattern of modern ink and wash painting's abstract character.

Wei's works show a lot of desire to communicate. What they express is a period of realistic experience, a kind of sentiment that words fail to convey. In these pictures filled with conscious experiences, sometimes there is the bewildering sense of religion, sometimes the strange transformation of images. All these private emotional experiences are expressed by the painter's rich artistic language. If we say there is something hidden inside the picture, which stimulates the painter to think and create its images beyond doubt, then we can say that, the transformation of images is the kernel to make the sentimental images appear.

Little by little, the young painter uses various symbols and techniques to accumulate with care. From the flowers and plants in nature, to a note in music, he can use anything as his objects. He can connect natural images and artistic languages with art images, then skillfully transform them as if he has magical powers. All of these are the appearance of his

delicate experiences as a contemporary artist in modern society, which is in complete agreement with the ambiguity of artistic languages without prior consultation.

The development of Wei's artistic language is firmly joined to the expression of realistic experiences. We can even learn from his works that the expression of realistic experiences is always in the essential position.

In addition, Wei has not been misled by current superficial criticism, and he does not stipulate a rigid topic, concerned with reality, or pile up realistic images. In fact, full of an unprecedented desire, he pays close attention to the reality of the soul, and to various effects, the society has on it. In his works, I have seen a relaxed state of his mind. He makes use of several kinds of patterns by each technique freely, using his works as a means to record his feelings. The sense of taking on the responsibility to make ink and wash recognized, and accepted, by more people is covered by the fun of strolling freely in this field. What he has done is just facing up to his own existence and his diverse identity, and trying to narrate it in the picture.

Actually, it is not that complicated at all - choosing ink and wash is simply choosing a language, which he believes, is hopeful; expressing is simply expressing one's own realistic feelings, not the attachment to a language. He believes, "I come from the East, so my works have the oriental nature; I am living in the modern period, so naturally my works have the modern manner; Wei says,' I'm thinking, so my works have the conceptual nature; and I'm looking forward to expressing, so my works have the possibility to communicate." It is true for Wei; while for me, this "arbitrary" attitude actually contains a kind of construction idea. For the young ink and wash painters, the intention to criticize has gone. To a certain extent, they do not say "No" angrily any more, but calmly explore "What we can do". Therefore, the meaning of Wei's works can be touched not only in the pictures itself, but also in his attitudes, which reveal a new attitude and suggest a new possibility. He tells us through his practice: the most important is not "What ink and wash is", but "What more can we do with ink and water".

April.1999, in Beijing

The article was formerly published in *Black and White History-Wei Qingji*, Hubei Fine Art Publishing House, 1999

"中国实验水墨展"，红门画廊，北京，2003
"Chinese Experimental Ink and wash Exhibition"，Red Gate Gallery，Beijing，2003

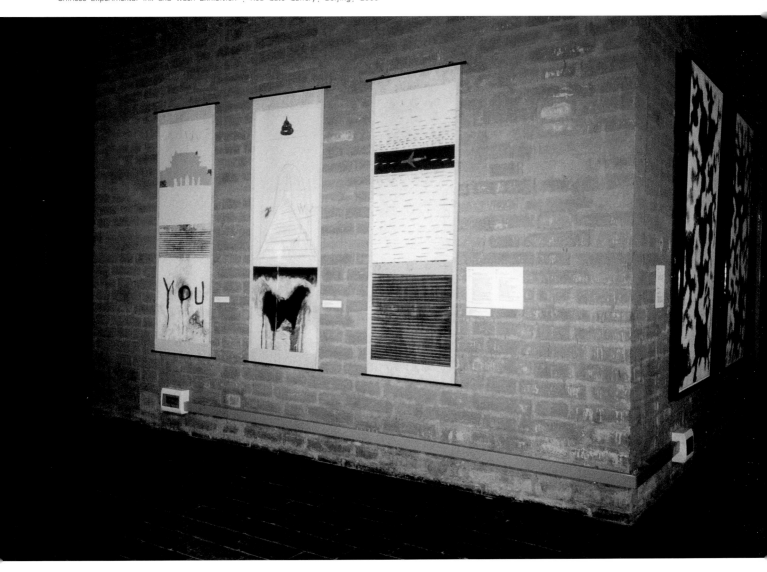

街头涂鸦（荷兰）
Doodle（Holland）

评论摘录
范迪安

魏青吉的作品是用各种符号和各种手法一点一点堆积起来的。它们所表现的是现实
体验的某个瞬间，某种无法诉诸语言的情愫。在这些充满感性体验的画面中，甚至
有某种迷幻的宗教感。实际上，在当代现实条件下，人们不断地经历、体验，同时也
不断地抛弃、忘却。而魏青吉则能将所有个人的生活与情感体验用丰富的语言记录
和表达出来，并且使作品充溢、弥漫着一种私秘性的气息。在他的象"日记"一样
的作品中，有一些图像符号是可以辩识的，它们与公共的经验有关，而更多的图像
在意义上是不确定的，它们只是某种感觉的载体。然而，如果说有什么东西刺激着画
家的创造和思考的话，那还是图像。对图像的敏感，对图像的转接是这些情绪化意
象出现的核心力量。

原载《第四届上海双年展画册》，上海美术馆，２００２年。

街头涂鸦（西班牙）
Doodle（Spain）

REVIEW

Fan Di-an

Wei Qingji's art works are created through a gradual accumulation of various signs and through different techniques. They depict a short flash of reality, a kind of feeling, which cannot be expressed with the language. There is even a mysterious sense of religion behind these subtle pictures. In fact, People in modern society continuously have experiences which they quickly forget. Wei Qingji records and displays his personal experiences with a rich visual language, and fills the works with a sense of intimacy. In his 'diary' pieces, some of the signs are recognizable, as they relate to common experiences, while some others are more cryptic, as they convey mere emotion. What stimulates the painter's creativity and consideration? Again, it is images. The richness and subtlety of images create the main strengths that are vibrating in his works.

Formerly Published in *The 4th ShangHai Biennale*, ShangHai Museum of Art, 2002

评论摘录
陈 侗

从表面上看魏青吉的水墨画与叙述无关，它们几乎完全属于图式论调——"技术"的纯度提炼和"学术化" ——所乐于发现的那种不同文化之间最理想和最体面的联姻。在批评家眼中它成功地实现了某种价值转换。然而，以我之见，要找出魏青吉与其他从事"实验水墨"的画家之间的区别，或者说确认他理解和实现抽象化的某种个人特点，惟有从他那简洁而极其透明的笔触中去考察不可能公开的对叙述的巧妙引入。可能的话，我们还将从作者风格的演变过程中观察到他为走出纯形式的谵妄——比方说"抽象水墨"对于"符号"的误解和滥用——而作出的努力。在他的依然透现着浓厚的文化关怀的文字表述中，他使用了"人文热情"、"人道主义"这些非视觉字眼，同时还提到了"走出'平面'"，"揭示那份被表象世界所掩盖的真实"，"试图在抽象与具象之间建立一种关系"。这个时候，无论作者是多么明确地表示要"努力消除画面的情节性因素"，他都进入到了超越情节的叙述漩涡中。其结果是，抽象水墨这个小概念不再适应于他，他的画面不再成为图式批评的靶心（批评将扩展至包括作者所谓"泛宗教"在内的精神范围），而是各种经验和感觉、思维和记忆出没无常的开阔场所。

原载《当代艺术》第16辑"中国当代水墨画"，湖南美术出版社，1999年。

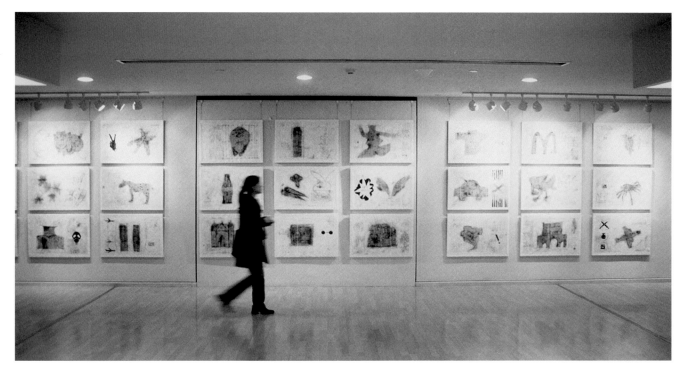

"第四届上海双年展",上海美术馆,2002
The 4th ShangHai Biennale, ShangHai Museum of Art, 2002

REVIEW

Chen Tong

Wei Qingji's ink and wash paintings seem to be foreign to narration, for they belong almost entirely to the most ideal and most decent marriage between different cultures, as is most ready to be found by schema theories, or pure abstraction of 'techniques' and 'academisation.' To some critics, Wei's works have succeeded in a sort of value transformation. In my point of view, however, it is only by observing, through his laconic and extremely transparent touche, how Wei invisibly and adeptly introduces narration. we can distinguish him from other painters of 'experimental ink and wash', and can decide whether he has understood and realized some sort of abstract individual characteristics. If possible, we might try to notice in the evolvement of his styles his efforts in walking out of pure formulist delirium, for instance, the misunderstanding and abuse of 'signs' in 'abstract ink and wash paintings.' In his writings, which are still permeated with strong cultural concerns, Wei uses such non-visual words as 'human enthusiasm' and 'humanism.' He also refers to 'walking out of "plane"', or "trying to build a kind of connection between the abstract and the concrete.' At these moments, he is deeply involved in a narrative whirlpool that transcends the plots, no matter how he declares explicitly that he would 'try his best to erase the elements of plots in the pictures.' As a result, the petite concept of 'abstract ink and wash painting' does not suit his works any more, and his pictures become a vast space, haunted by various experiences, senses, memories and thinking, instead of mere targets of schema criticism which extend as far as into the spiritual realm, including what the author calls 'pan-religion.'

Formerly Published in *Contemporary Art*, Hunan Fine Arts Press, 1999.

评论摘录
皮道坚

90 年代的中国实验水墨画家群中如果少了魏青吉，难免会使一些人产生 "红旗到底能打多久？" 的疑问，因为持悲观主义态度的批评家早就作了水墨画在形态意义和文化指向上将彻底失效的判断。而魏青吉的出现，不仅在年龄层次上让人感到现代水墨画事业方兴未艾，更重要的是他的作品向我们提示了水墨性绘画转变为一种开放性语言的新的可能性。

与 80 年代以来所有从事探索性水墨艺术创作的画家不同，魏青吉似乎不曾有过在东方与西方、传统与现代的二元对立中艰难抉择的困惑与苦恼。他只是自然而然地运用自己喜爱的艺术媒材去 "展现隐藏在我们生活背后的真实"，并且通过在画面上营造观念的方法为当代生活 "注入一种泛宗教化的意识"（引文摘自画家笔记）。在这一点上他又与大多数活跃于 90 年代画坛的实验性水墨画家一样，对现代化和高科技发展所带来的人性与自然性丧失始终保持应有的警惕。值得注意的是他用以营造悬念的方法，不仅包括新水墨艺术中流行的拓印、拼贴和大面积使用白粉等现代制作手法，还包括自如地使用一些非水墨工具和材料。他让铅笔的尖锐刺痕、喷漆的覆盖感与水渍的流动浸润一起去诉说生命和生活的体验，带给我们前所未有的奇妙感受，也向我们证实了现代水墨语言的开放性和无边性。

原载《九十年代中国实验水墨》香港世界华人艺术出版社，1998 年。

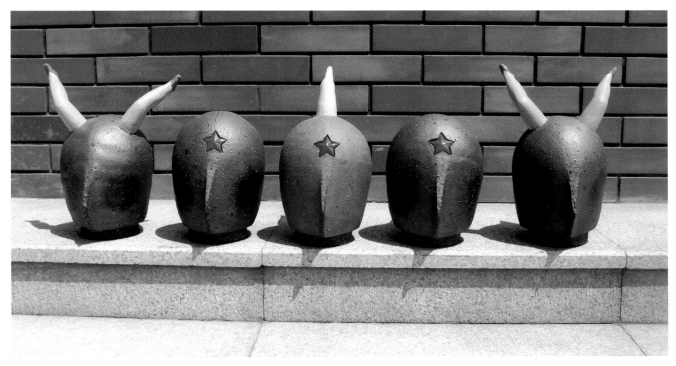

陶系列－英雄
陶
Pottery Series—Heroes
Pottery
22 x 22 x 31 cm x 5
2002

REVIEW

Pi Daojian

If there had been no Wei Qingji among the Chinese experimental ink and wash painters in 1990s, some might inevitably raise questions like; 'how long on earth can the red flag stand.' For pessimistic critics have long before judged that the ink and wash would become completely invalid, both morphologically and in the sense of cultural orientation. The advent of Wei, however, makes one feel that, in relation to his young age, the cause of modern ink and wash is in the ascendant, and more importantly, his works remind us of a new possibility of turning ink and wash paintings into an open language.

Different from all other painters engaged in explorative ink and wash creation, Wei seems to have no such perplexes or miseries of having to choose between the East and the West, or between the traditional and the modern. He simply exploits spontaneously the artistic media he likes, to 'display the real hiding behind our lives,' and 'to impregnate a pan-religious consciousness' (Wei's own words, quoted from his painting notes) into the contemporary life by means of constructing concepts onto the pictures. In this respect, he comes close to most experimental ink and wash painters active in the 1990s painting circle, for they all guard against the loss of humanity and naturalness brought about by modernization and the development of high-tech.

It is worth noting the ways in which Wei constructs a kind of suspense, including rubbing inscriptions, pastiche, and the wide use of white powders in a large area, all popular among new ink and wash arts. He also exploits freely some non-ink-and-wash instruments and materials. The sharp inscriptions of the pencil, the covering of spray-paint, and the liquid immersion of water stain, all recount his experiences of life and lives, introducing to us a kind of curious feeling that we have never experienced before. In this way, Wei proves to us the openness and infinity of modern ink and wash painting.

Formerly Published in *90s' Chinese Experimental Ink and Wash Painting*, World Chinese Art Press, Hong Kong, 1998.

作　品　WORKS

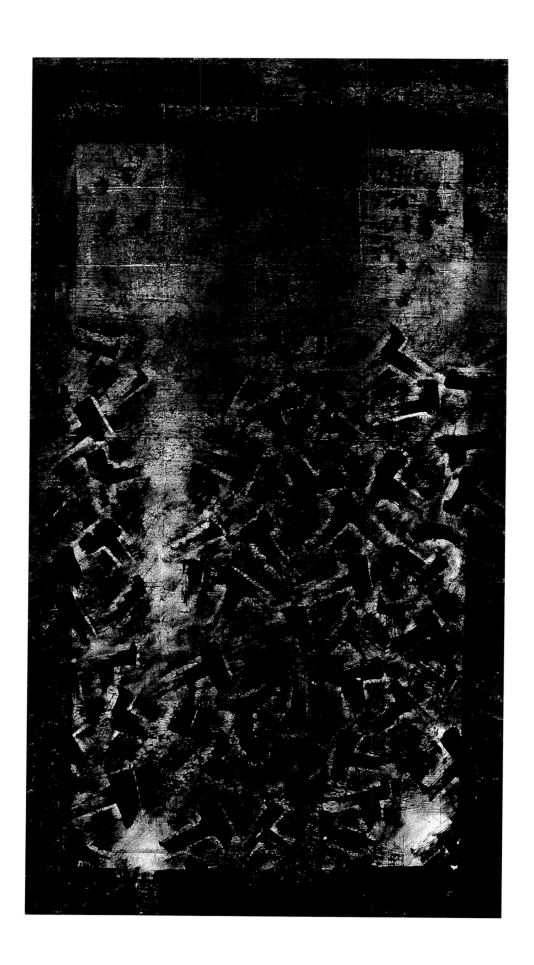

关于 T 系统的构想 No.11
宣纸　水墨
Ideas about T Systems No.11
Ink on Rice Paper
180 x 95 cm
1996

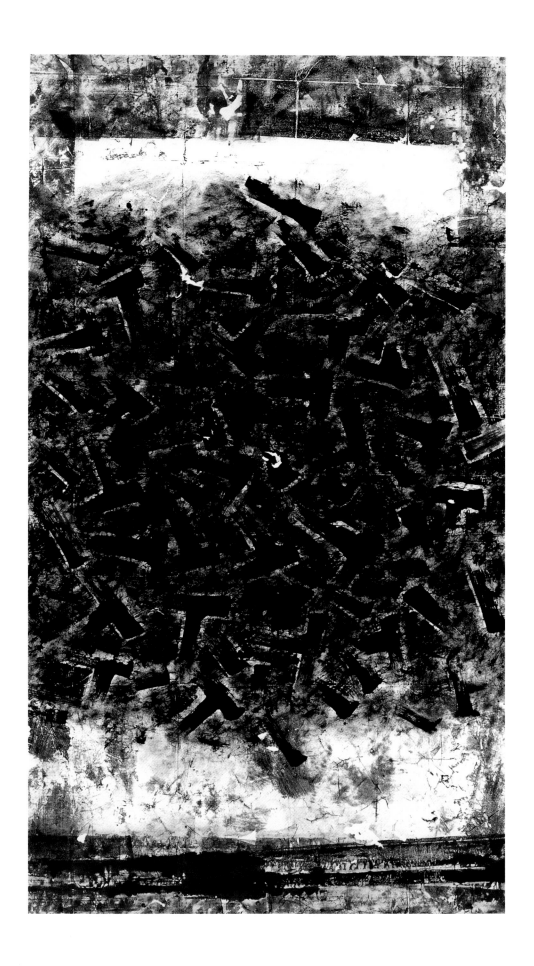

关于 T 系统的构想No.12
宣纸　水墨
Ideas about　T Systems No.12
Ink on Rice Paper
180 x 95 cm
1996

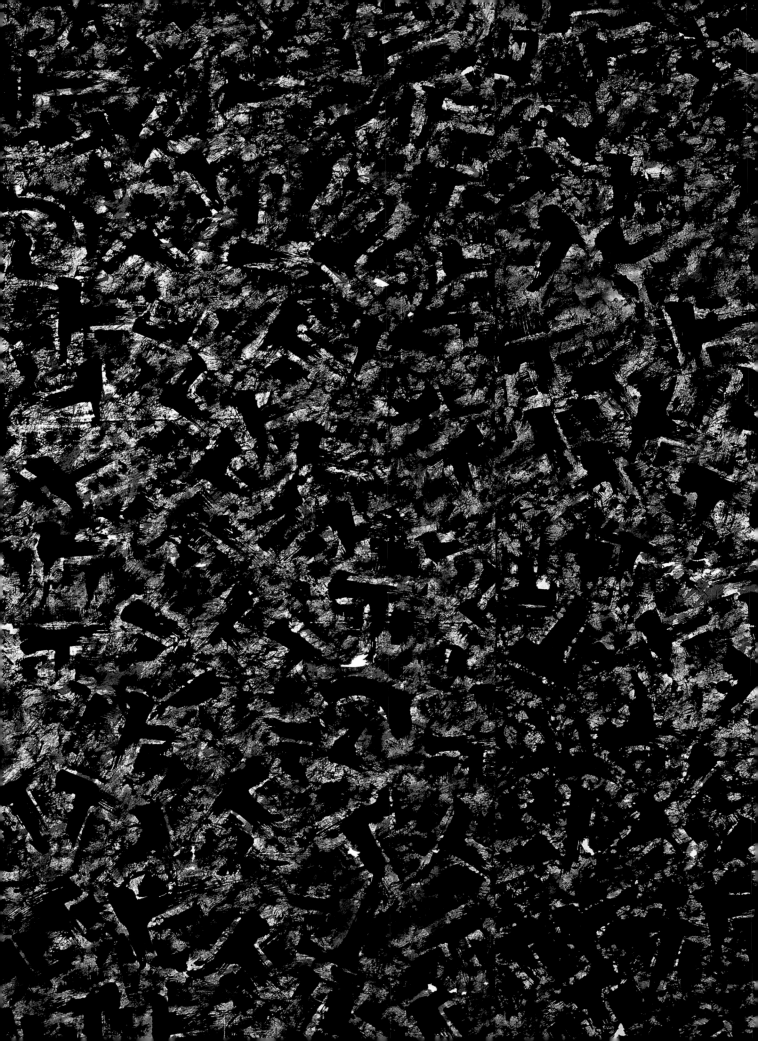

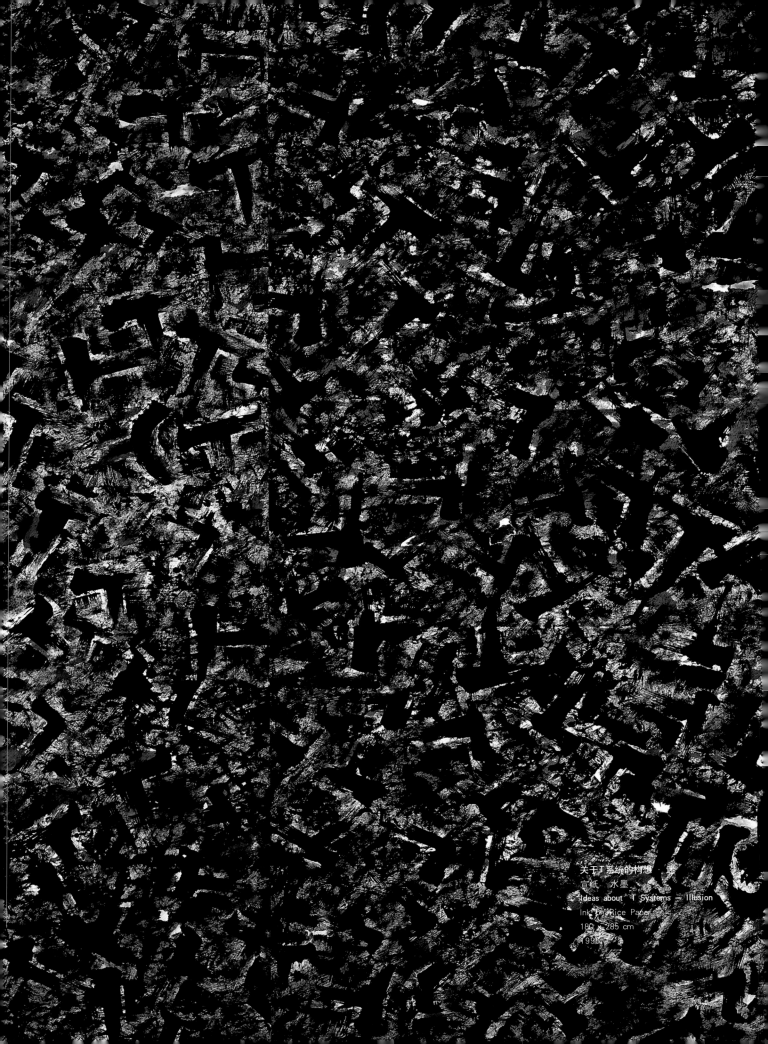

关于丁系统的构想・迷
宣纸　水墨
Ideas about 'T' Systems – Illusion
Ink on Rice Paper
180 × 285 cm
1995

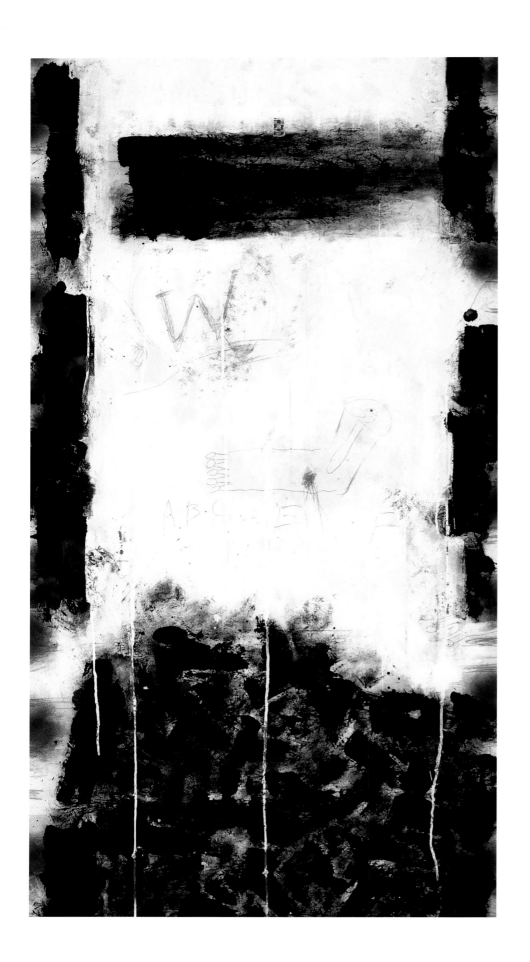

修复记忆的方式No.1
宣纸　水墨 铅笔 白粉 茶
The Way to Repair Memory No.1
Ink，Pencil，White Chalk，Tea
on Rice Paper
180 x 95 cm
1996

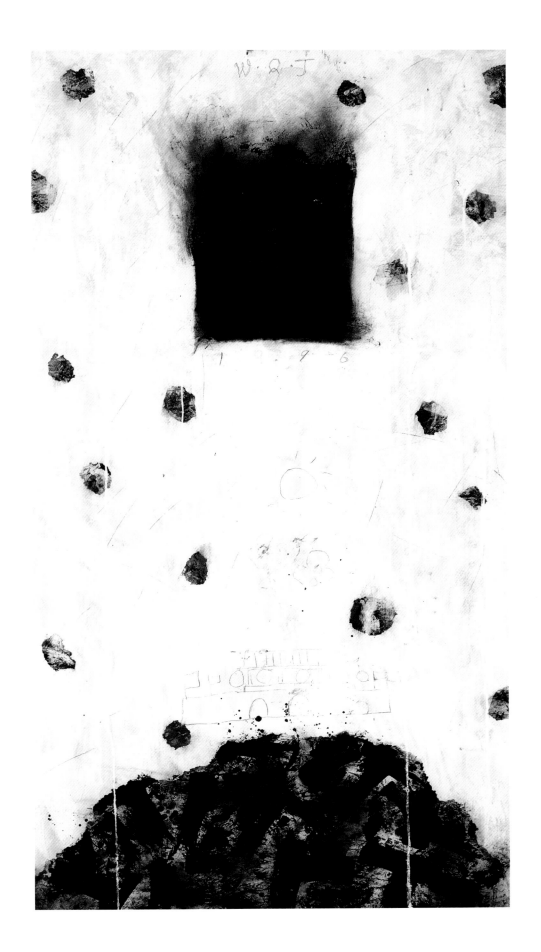

修复记忆的方式 No.2
宣纸 水墨 铅笔 白粉 茶
The Way to Repair Memory No.2
Ink, Pencil, White Chalk, Tea
on Rice Paper
180 x 95 cm
1996

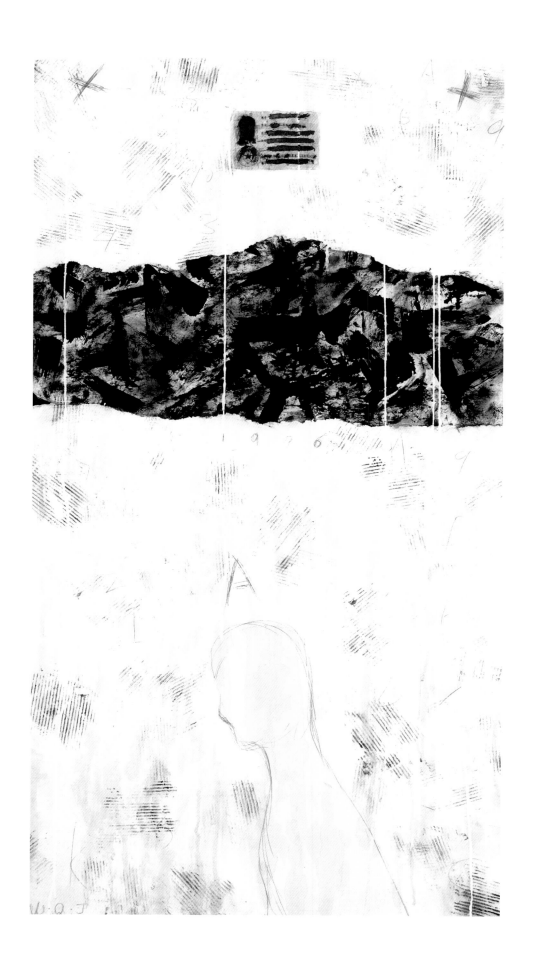

修复记忆的方式No.3
宣纸 水墨 铅笔 白粉 茶
The Way to Repair Memory No.3
Ink, Pencil, White Chalk, Tea
on Rice Paper
180 x 95 cm
1996

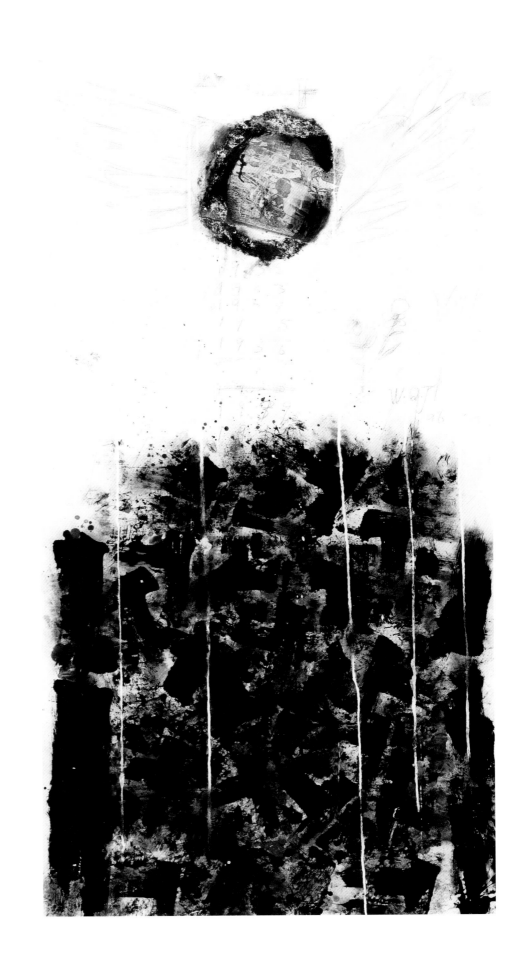

修复记忆的方式No.4
宣纸 水墨 铅笔 白粉 茶
The Way to Repair Memory No.4
Ink, Pencil, White Chalk, Tea
on Rice Paper
180 x 95 cm
1996

修复记忆的方式No.5
宣纸 水墨 铅笔 白粉 茶
The Way to Repair Memory No.5
Ink, Pencil, White Chalk, Tea
on Rice Paper
180 x 95 cm
1996

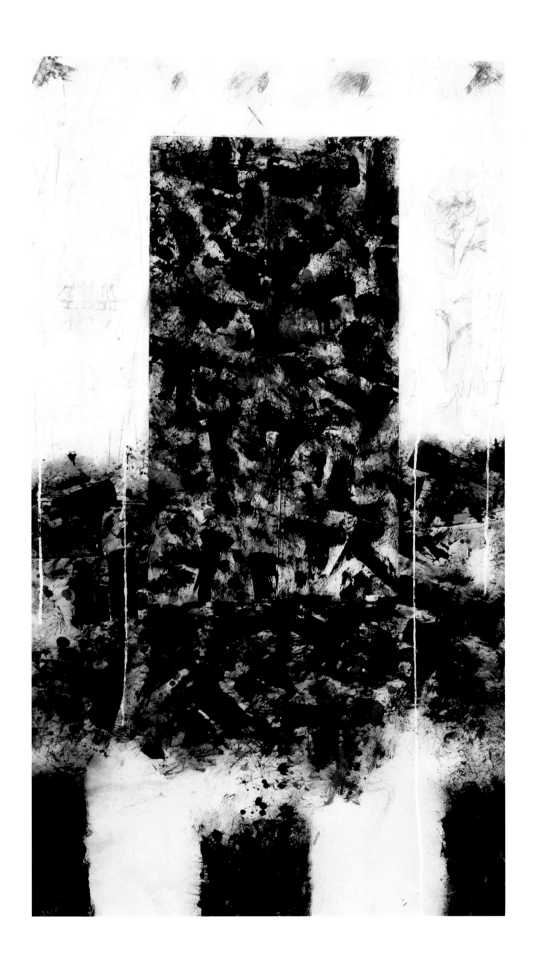

非情节性叙述No.2
宣纸　水墨 铅笔 白粉 茶
Plotless Narration No.2
Ink, Pencil, White Chalk, Tea
on Rice Paper
180 x 95 cm
1997

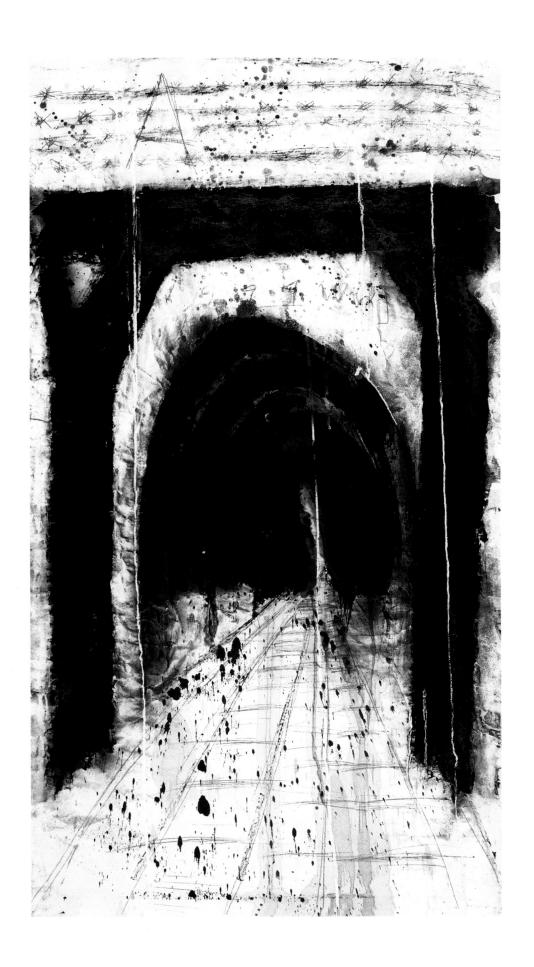

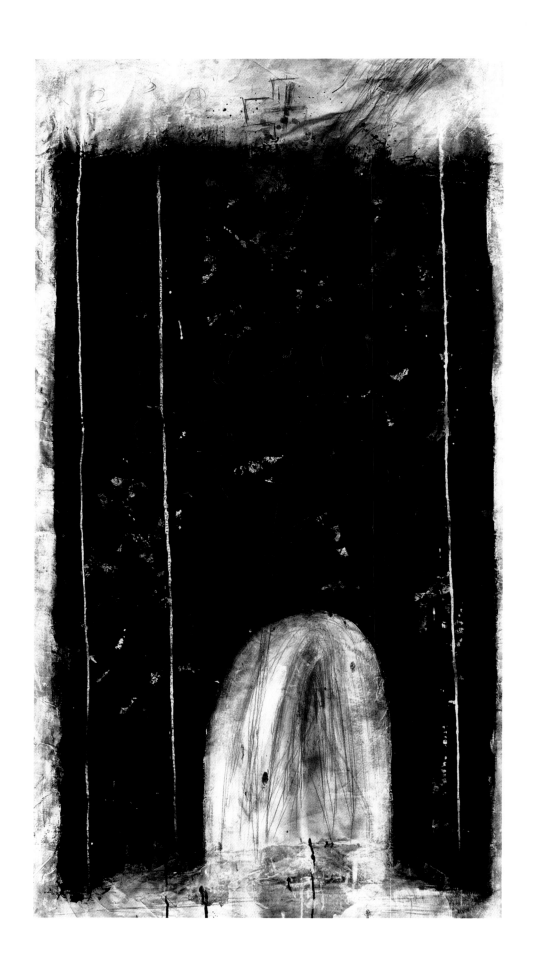

非情节性叙述No.3
宣纸 水墨 铅笔 白粉 茶
Plotless Narration No.3
Ink, Pencil, White Chalk, Tea
on Rice Paper
180 x 95 cm
1997

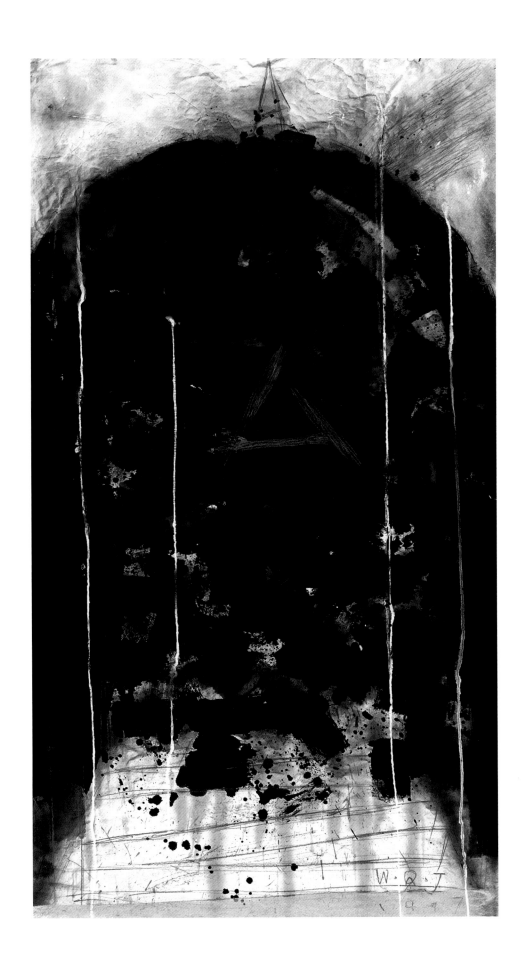

非情节性叙述No.5
宣纸　水墨　铅笔　白粉　茶
Plotless Narration No.5
Ink, Pencil, White Chalk, Tea
on Rice Paper
180 x 95 cm
1997

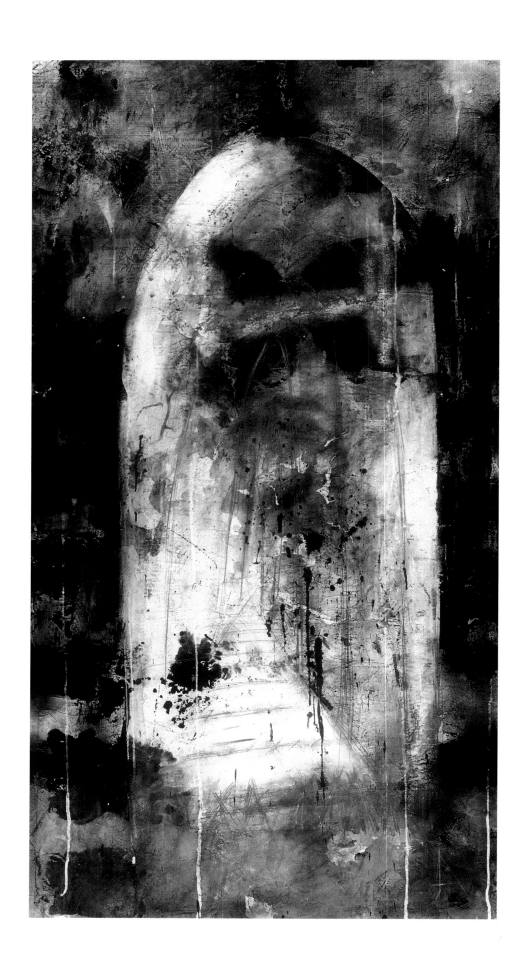

非情节性叙述 No.9
宣纸 水墨 铅笔
白粉 茶
Plotless Narration No.9
Ink, Pencil, White Chalk, Tea
on Rice Paper
180 x 100 cm
1998

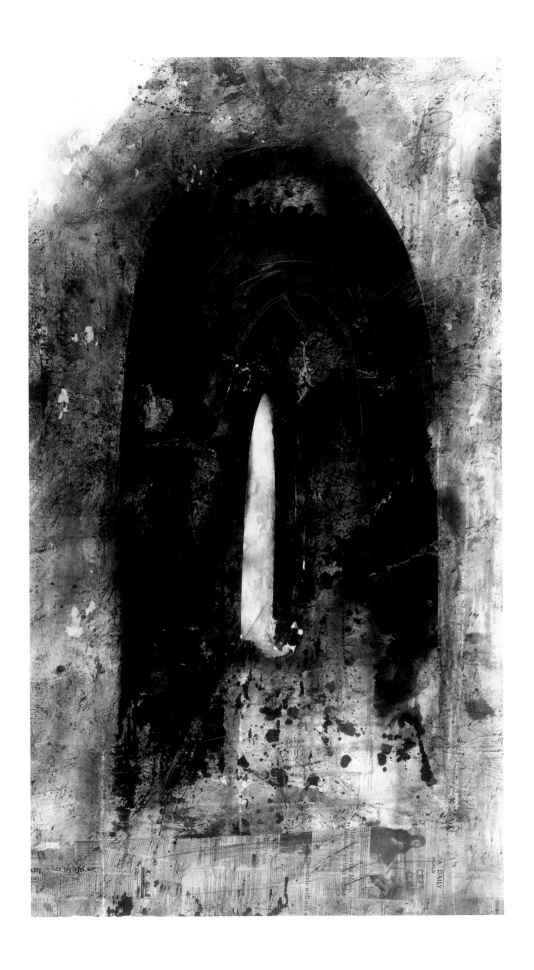

非情节性叙述No.10
宣纸 水墨 铅笔
白粉 茶
Plotless Narration No.10
Ink，Pencil，White Chalk，Tea
on Rice Paper
180 x 100 cm
1998

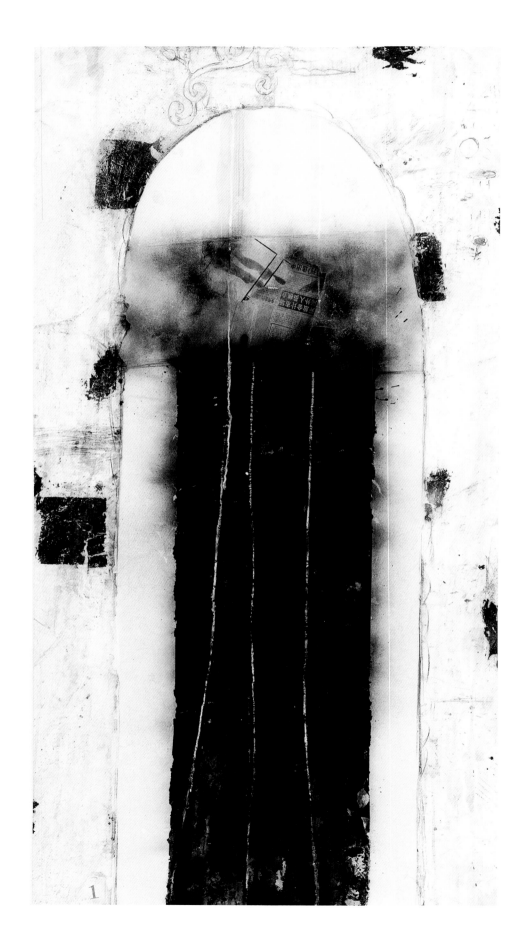

非情节性叙述No.11
宣纸 水墨 铅笔
白粉 茶 金箔
Plotless Narration No.11
Ink, Pencil, White Chalk, Gold Foil, Tea
on Rice Paper
180 x 95 cm
1997

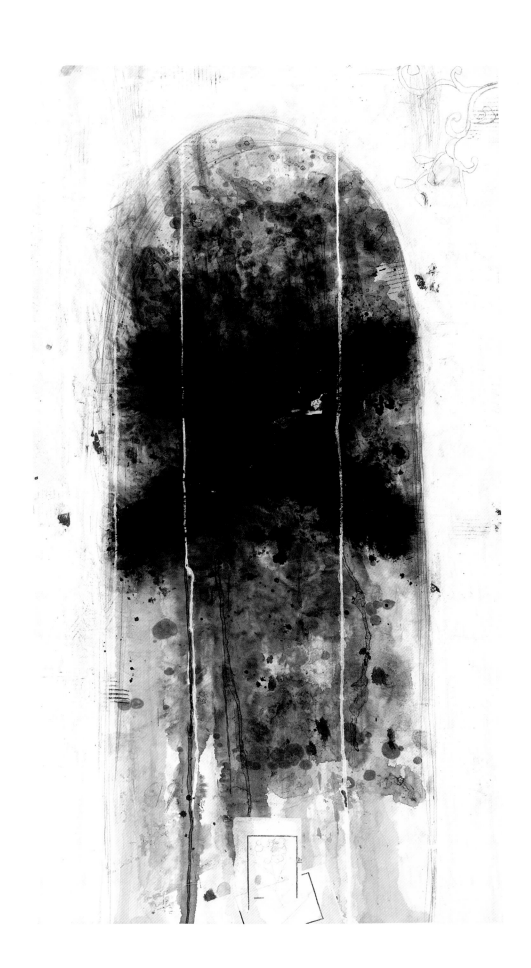

非情节性叙述No.12
宣纸　水墨 铅笔
白粉　茶
Plotless Narration No.12
Ink，Pencil，White Chalk，Tea
on Rice Paper
180 x 95 cm
1997

就象花儿一样No.1
宣纸　水墨 铅笔 白粉 茶
Just like flower No.1
Ink，Pencil，White Chalk， Tea
on Rice Paper
185 x 95 cm
1997

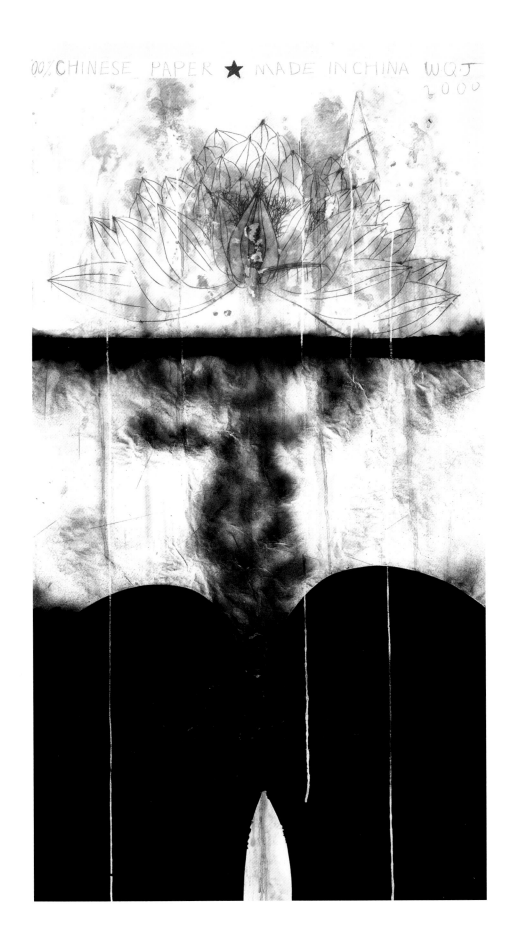

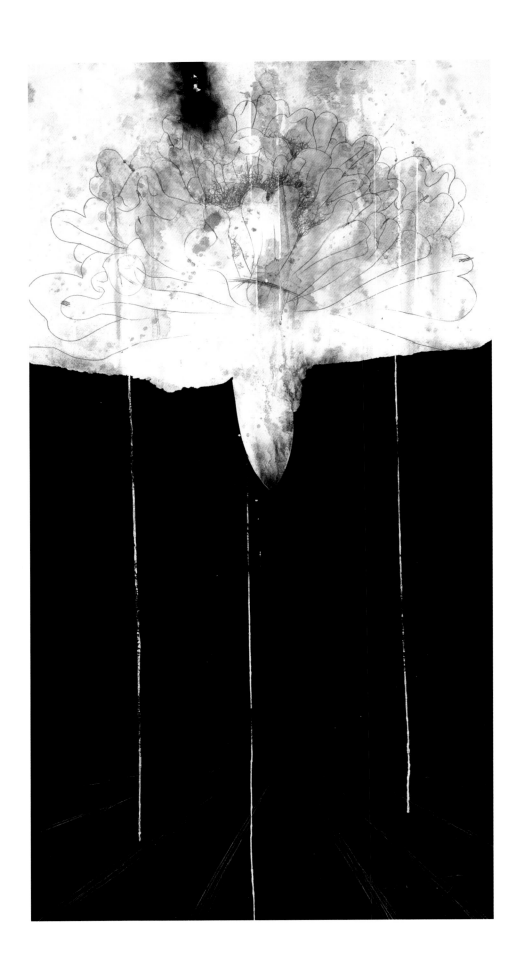

就象花儿一样No.2
宣纸 水墨 铅笔 白粉 茶
Just like flower No.2
Ink，Pencil，White Chalk，Tea
on Rice Paper
185 x 95 cm
1997

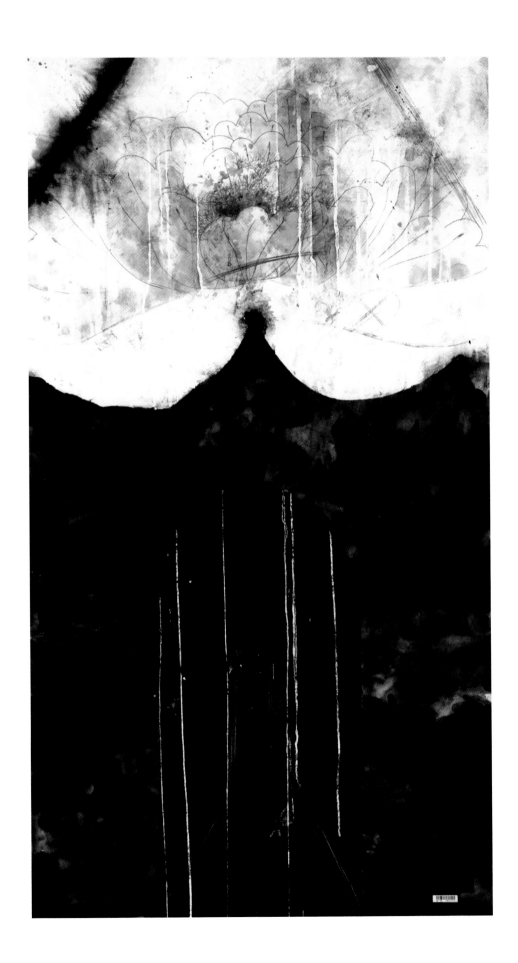

就象花儿一样No.3
宣纸　水墨　铅笔　白粉　茶
Just like flower No.3
Ink，Pencil，White Chalk，Tea
on Rice Paper
185 x 95 cm
1997

记忆的属性No.2
宣纸 水墨 铅笔 茶 白粉
The Property of Memory No.2
Ink，Pencil，White Chalk，Tea
on Rice Paper
180 x 195 cm
1999

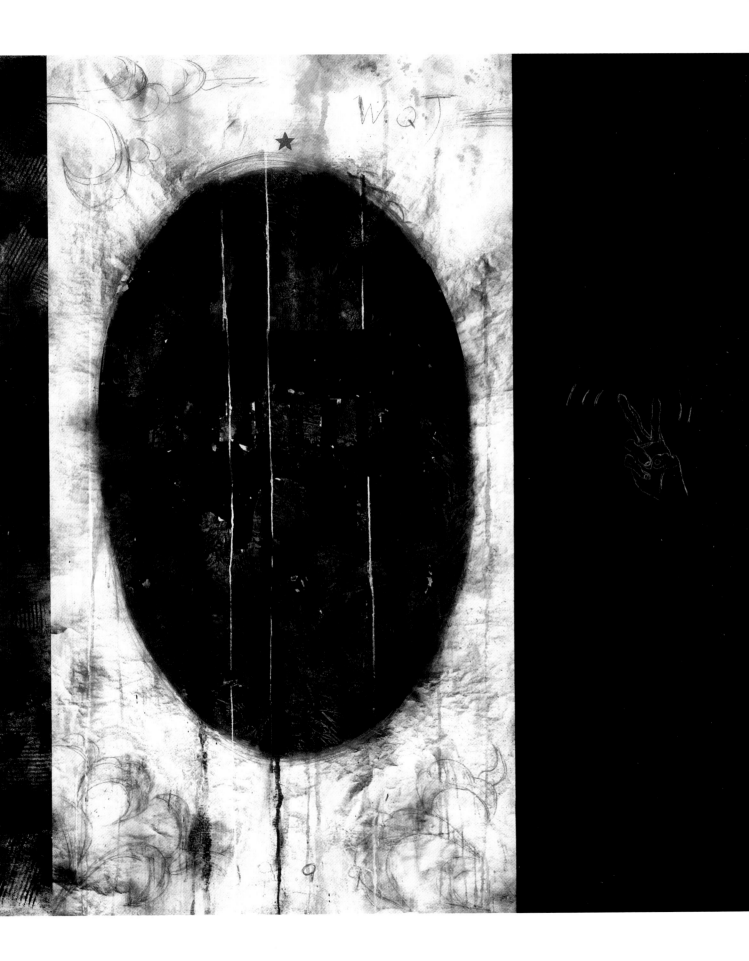

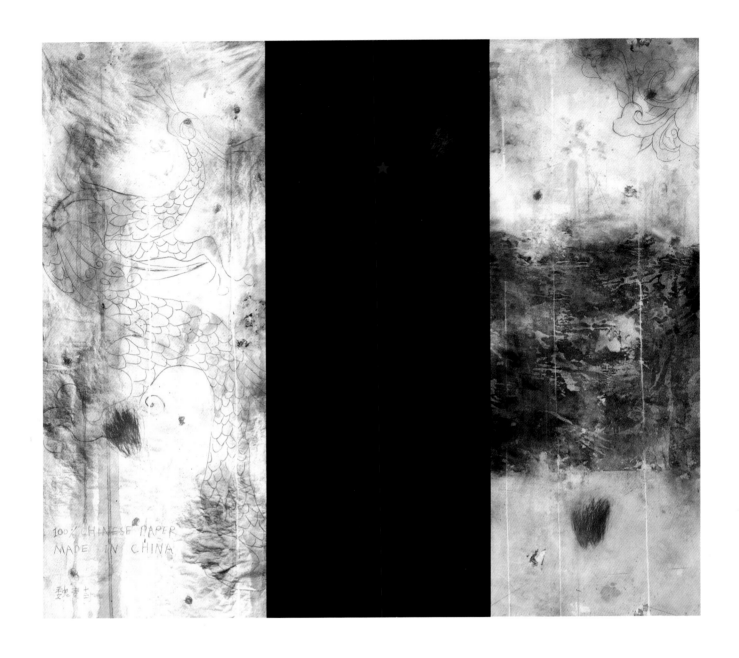

记忆的属性No.3
宣纸 水墨 铅笔 茶 白粉
The Preperty of Memory No.3
Ink, Pencil, White Chalk, Tea
on Rice Paper
180 x 195 cm
1999

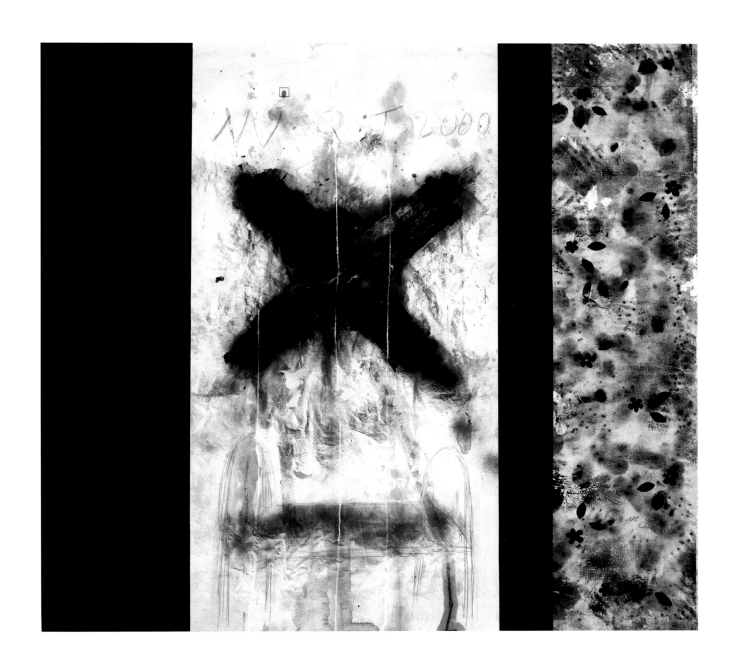

记忆的属性 No.4
宣纸　水墨　铅笔　茶　白粉
The Preperty of Memory No.4
Ink, Pencil, White Chalk, Tea
on Rice Paper
180 x 195 cm
1999

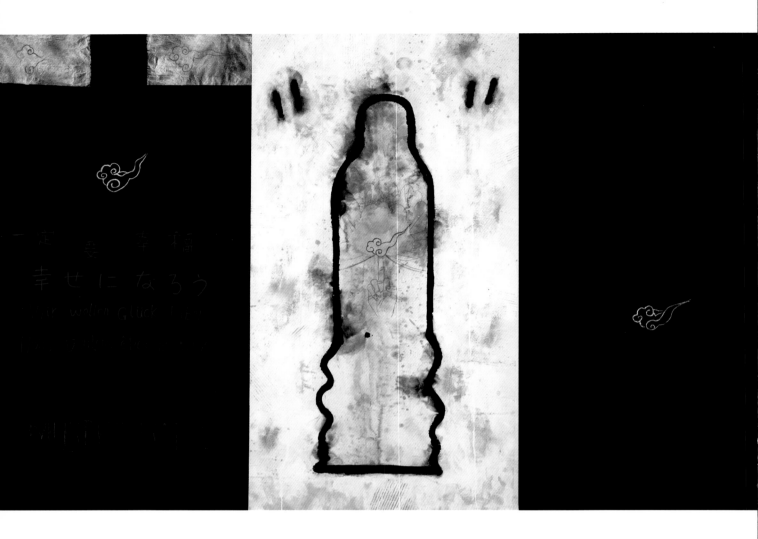

幸福的属性
宣纸　水墨　铅笔　白粉　茶　粉笔
The Property of Happiness and Fortune
Ink、Pencil、Chalk、Tea on Rice Paper
180 x 560 cm
1999

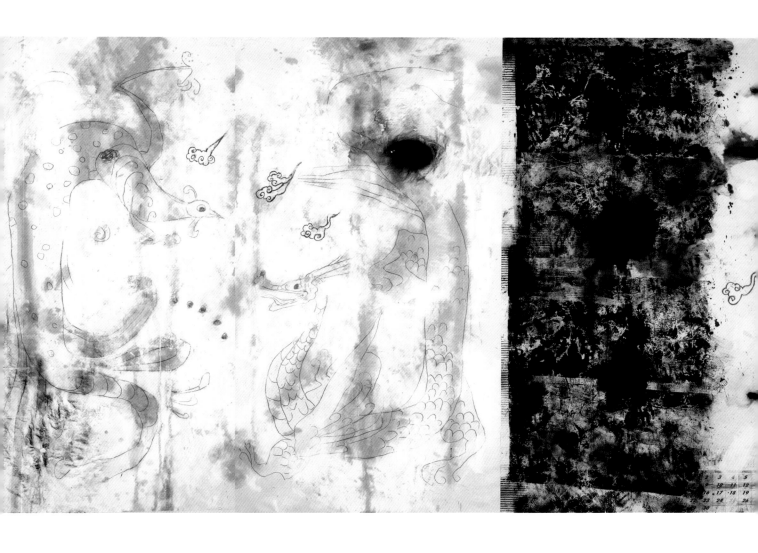

如何以日常的方式叙述No. 2
宣纸　水墨　铅笔　白粉　金箔　茶
How to Explain in an Usual Way No. 2
Ink, Pencil, White chalk, Gold foil, Tea
on Rice Paper
195 x 180 cm
2001

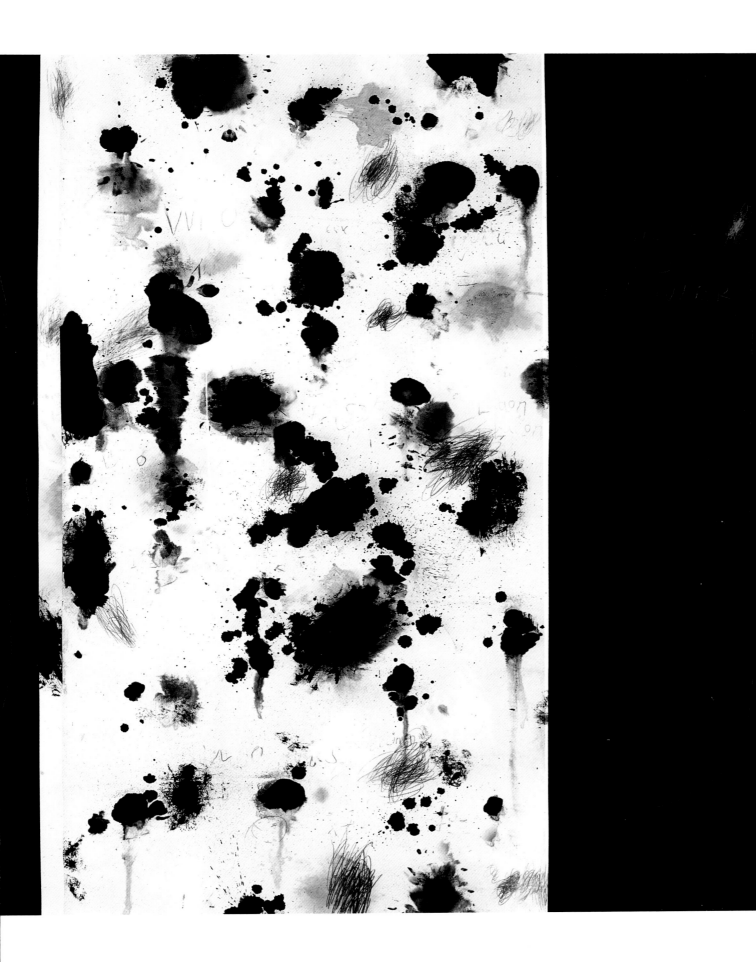

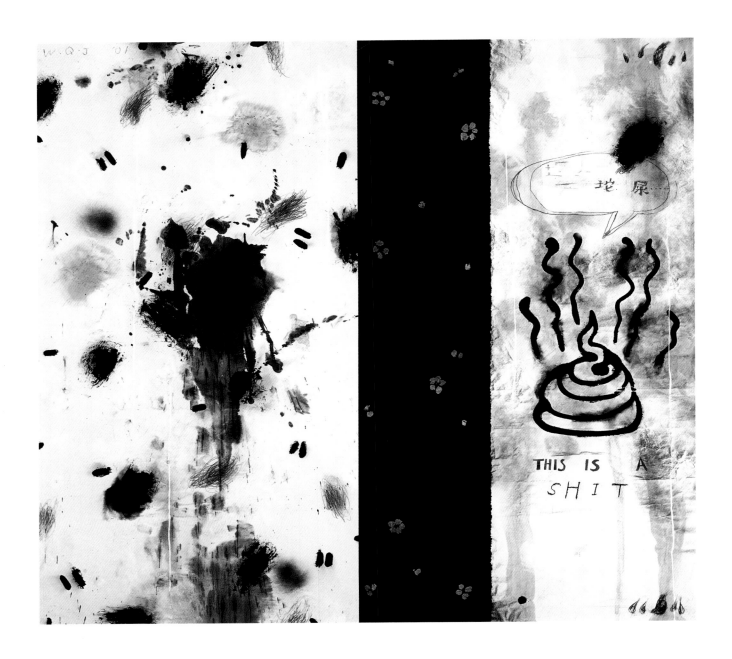

如何以日常的方式叙述No.1
宣纸　水墨 铅笔 白粉 金箔 茶
How to Explain in an Usual Way No.1
Ink，Pencil，White Chalk，Gold Foil，Tea
on Rice Paper
195 x 180 cm
2001

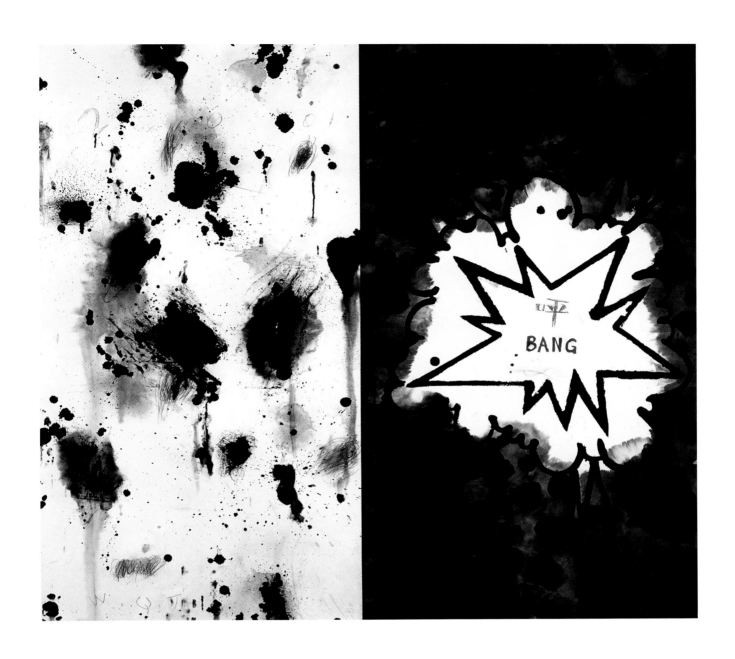

如何以日常的方式叙述 No. 3
宣纸 水墨 铅笔 白粉 金箔 茶
How to Explain in an Usual Way No. 3
Ink，Pencil，White Chalk，Gold Foil，Tea
on Rice Paper
195 x 180 cm
2001

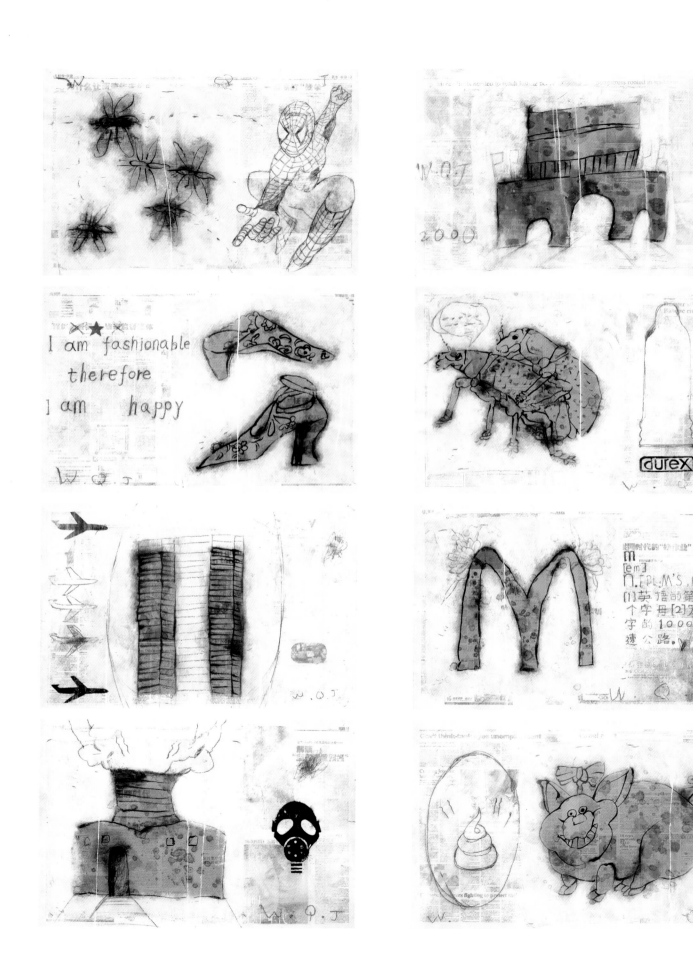

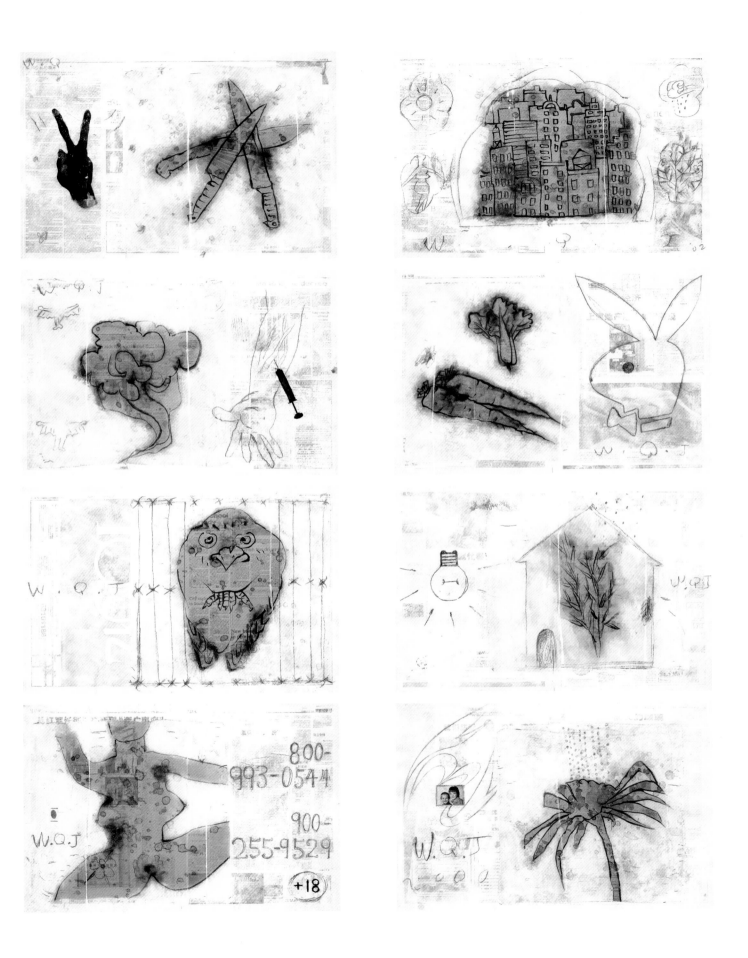

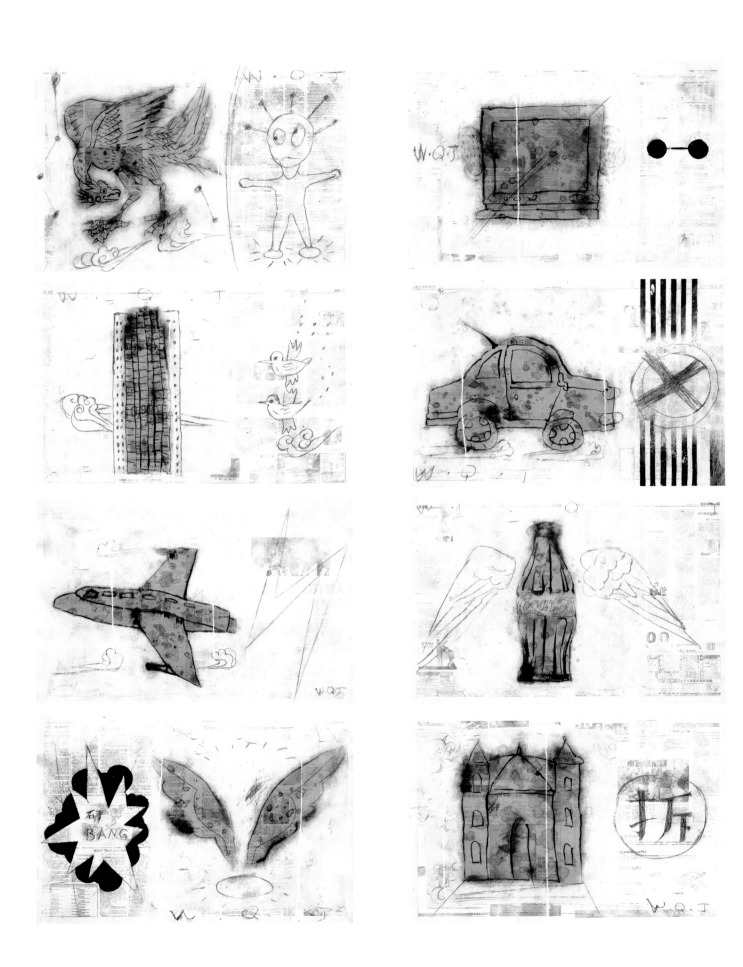

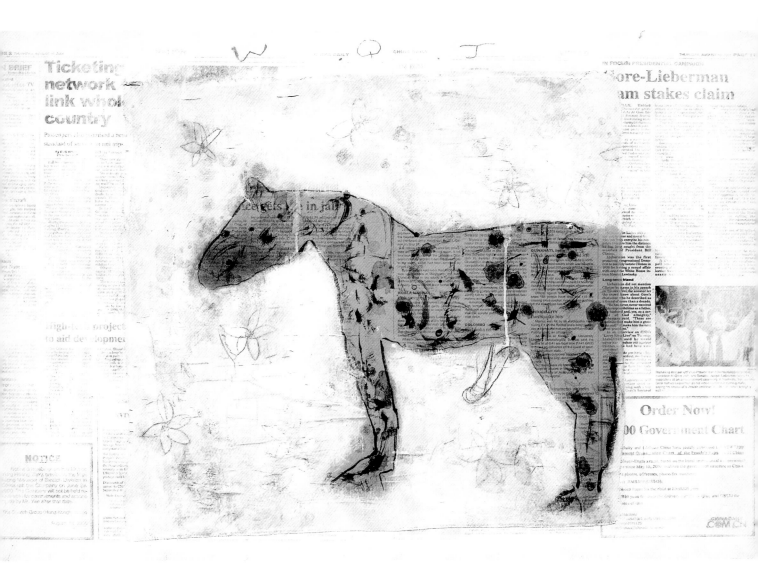

P72—75

日常生活的属性No.1—30

绢　报纸　水墨综合材料

Attribution of Everyday life No.1—30

Mixed Media on Silk and Newspaper

78 × 55 cm × 30

2000

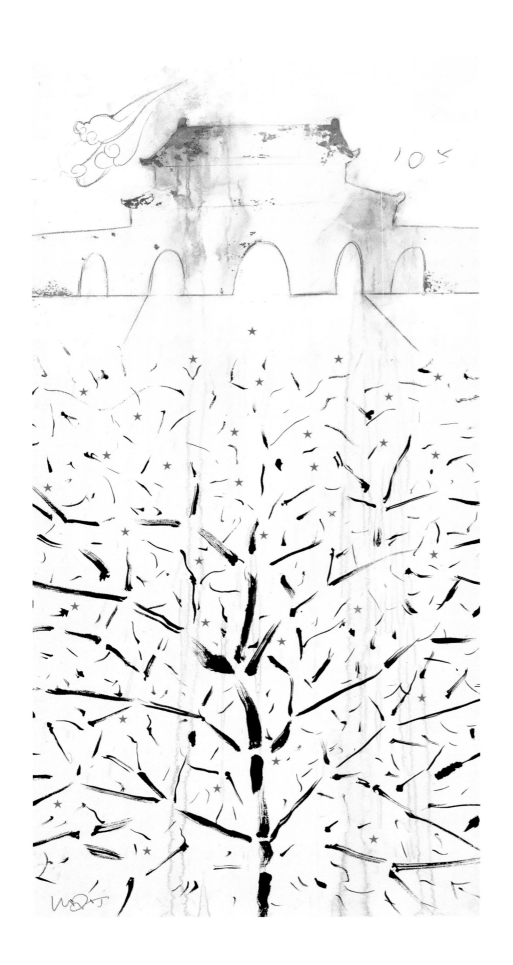

定点风景写生No.1
宣纸　水墨综合材料
Scenery Research, No.1
Ink and Mixed Media on
Rice Paper
136 x 68 cm
2005

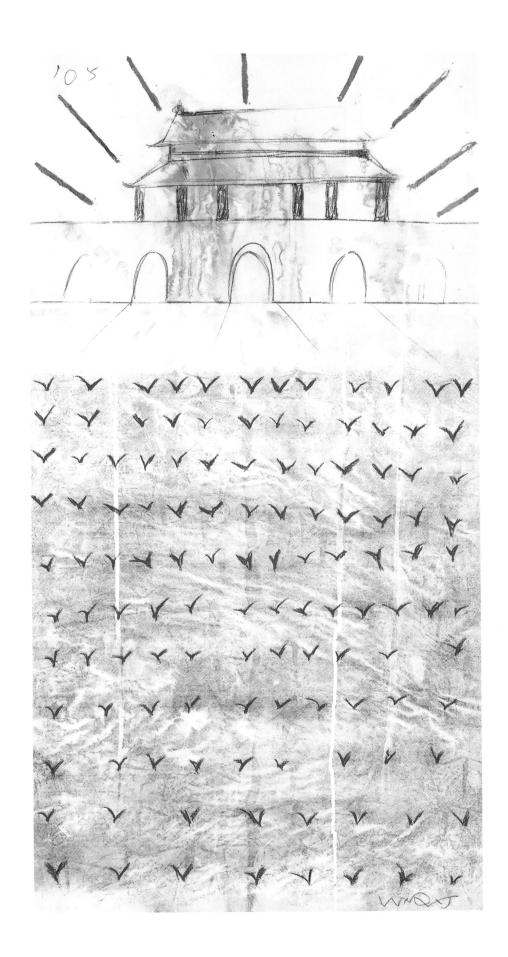

定点风景写生No.2
宣纸　水墨综合材料
Scenery Research, No.2
Ink and Mixed Media on
Rice Paper
136 x 68 cm
2005

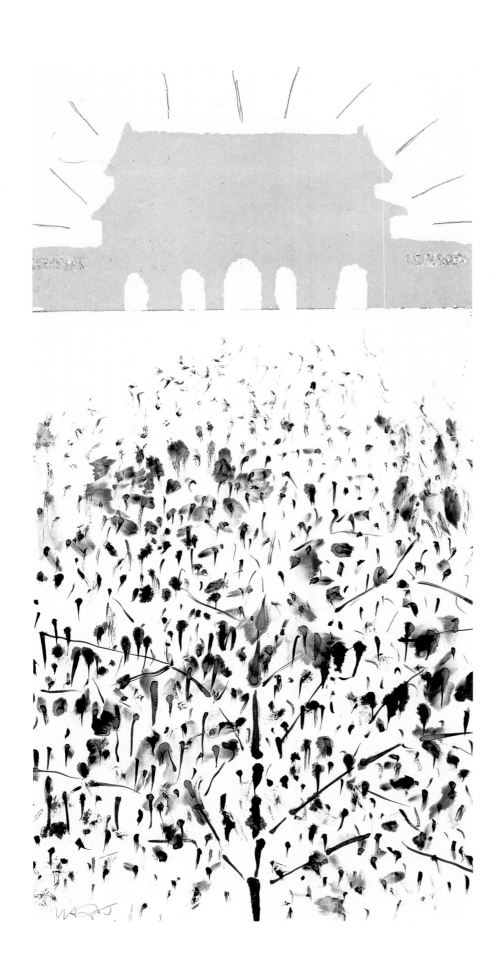

定点风景写生No.3
宣纸　水墨综合材料
Scenery Research, No.3
Ink and Mixed Media on
Rice Paper
136 x 68 cm
2005

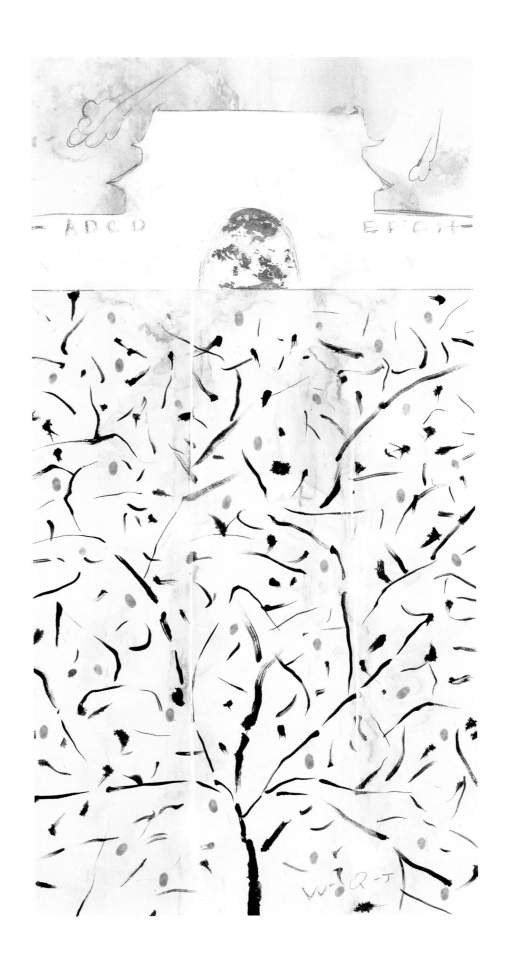

定点风景写生No.4
宣纸　水墨综合材料
Scenery Research, No.4
Ink and Mixed Media on
Rice Paper
136 x 68 cm
2005

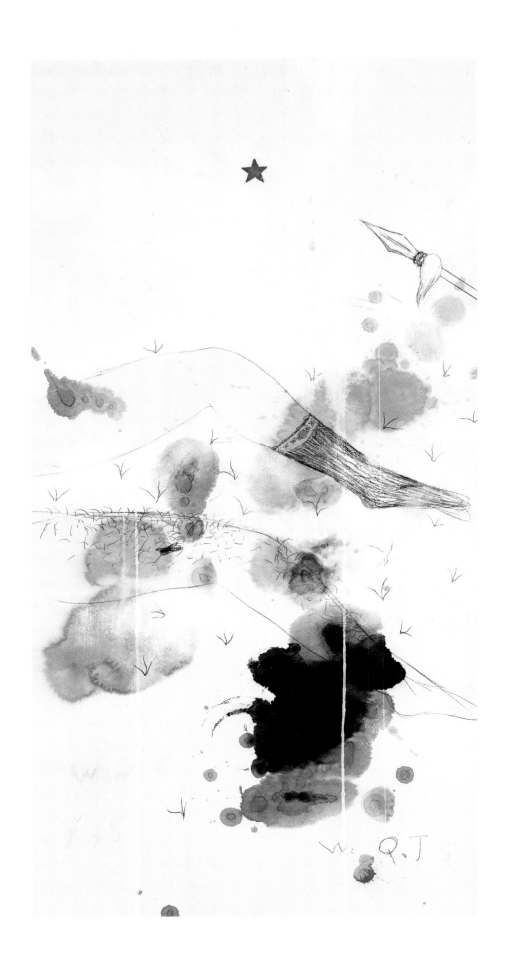

革命的风景No.1
宣纸　水墨综合材料
Revolutionary Sence No.1
Ink and Mixed Media
on Rice Paper
136 x70 cm
2005

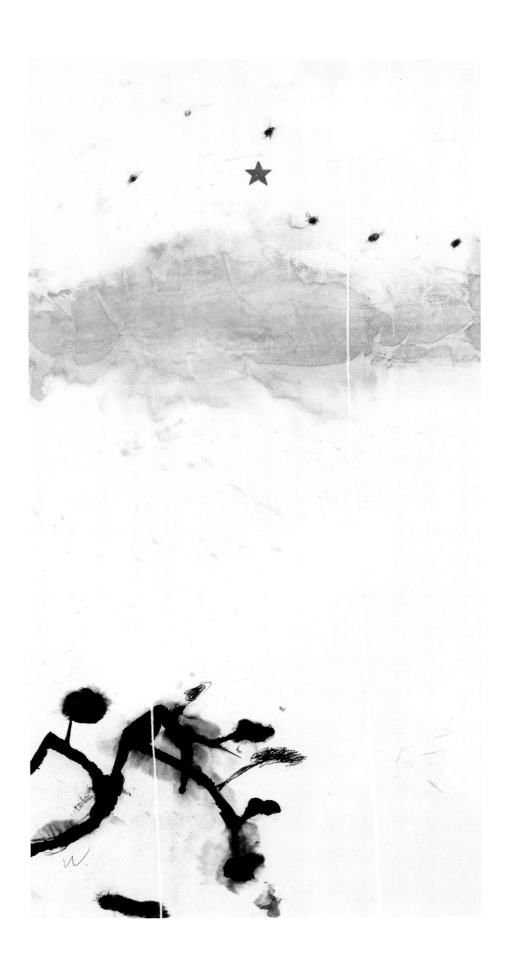

革命的风景 No.2
宣纸 水墨综合材料
Revolutionary Sence No.2
Ink and Mixed Media
on Rice Paper
136 x 70 cm
2005

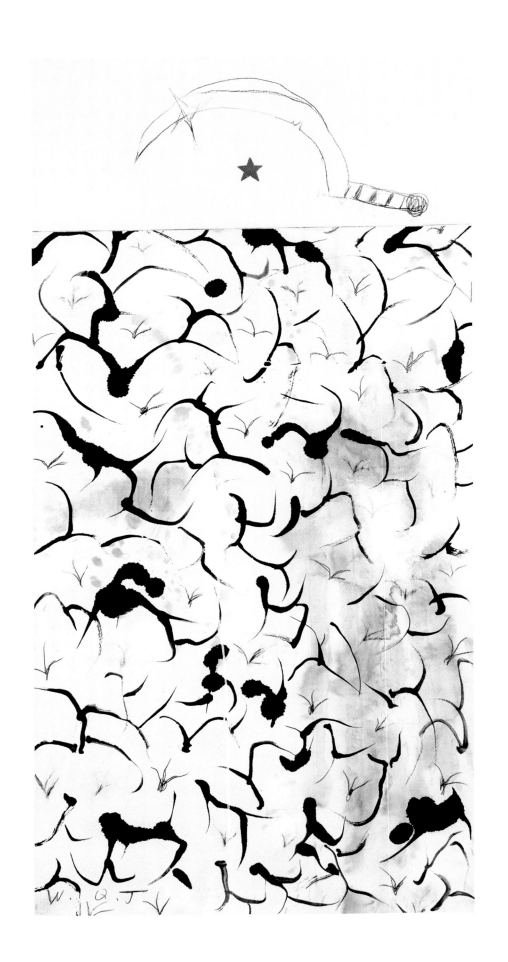

革命的风景No.3
宣纸　水墨综合材料
Revolutionary Sence No.3
Ink and Mixed Media
on Rice Paper
136 x 70 cm
2005

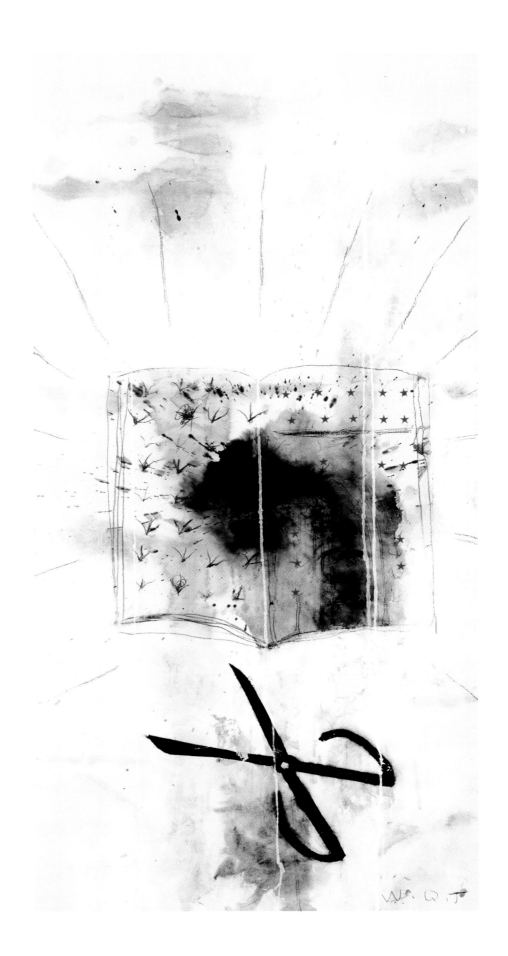

革命的风景No.4
宣纸　水墨综合材料
Revolutionary Sence No.4
Ink and Mixed Media
on Rice Paper
136 x 70 cm
2005

五只蚂蚁
宣纸　水墨综合材料
Five Ants
Ink and Mixed Media
on Rice Paper
68 x 136 cm
2003

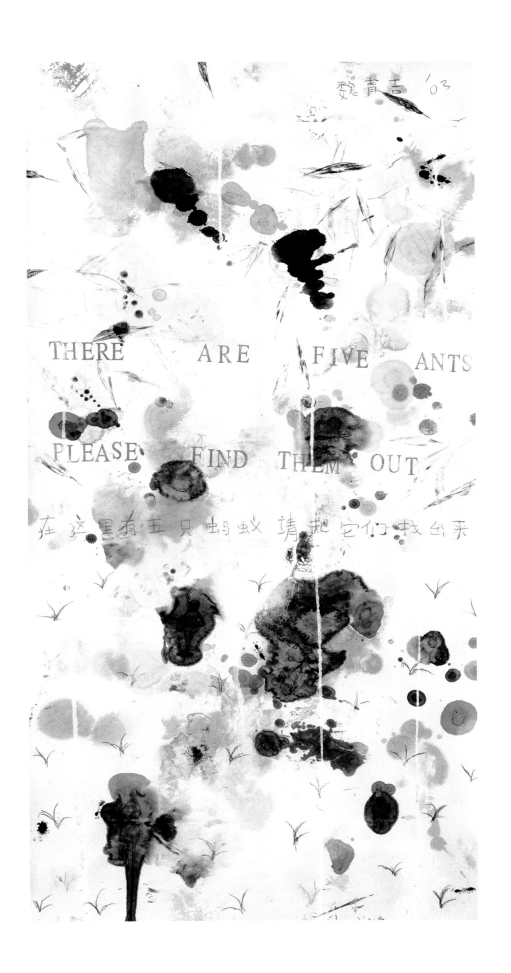

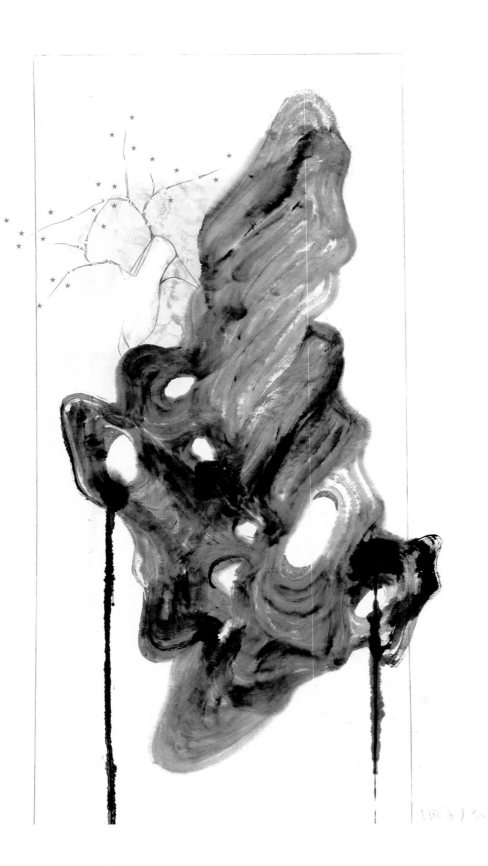

异化的风景－太湖石1号
宣纸　水墨综合材料
Unusual Scene No.1
Ink and Mixed Media
on Rice Paper
206 x 125 cm
2004

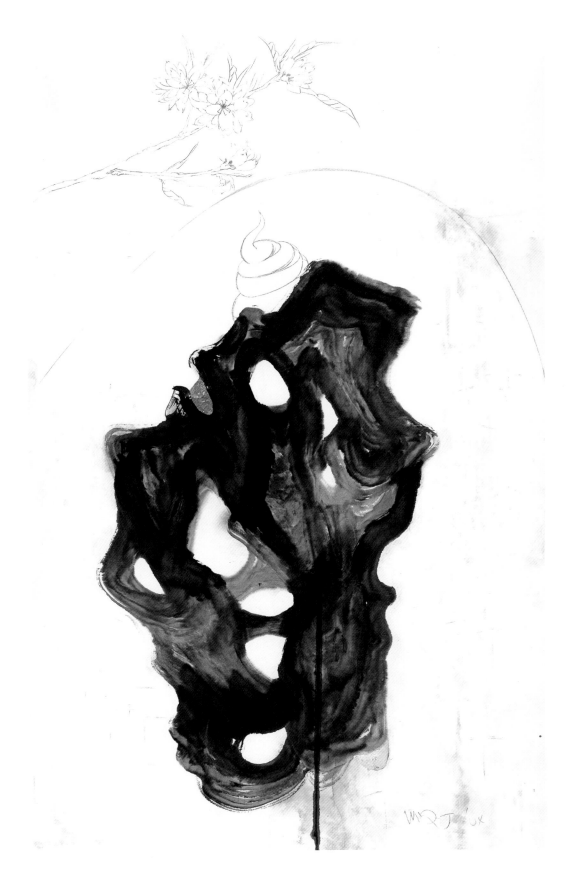

异化的风景－太湖石2号
宣纸　水墨综合材料
Unusual Scene No.2
Ink and Mixed Media
on Rice Paper
2004

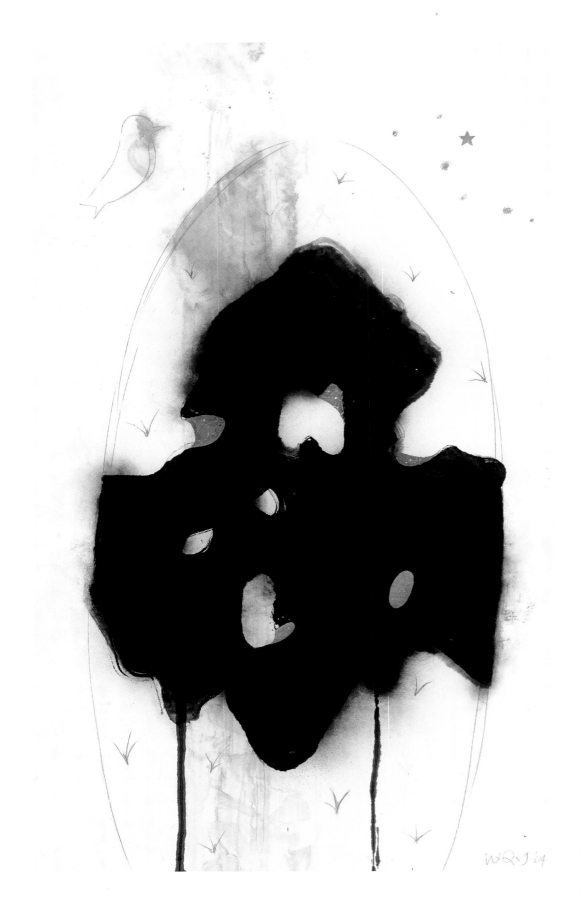

异化的风景－太湖石3号
宣纸　水墨综合材料
Unusual Scene No. 3
Ink and Mixed Media
on Rice Paper
206 x 125 cm
2004

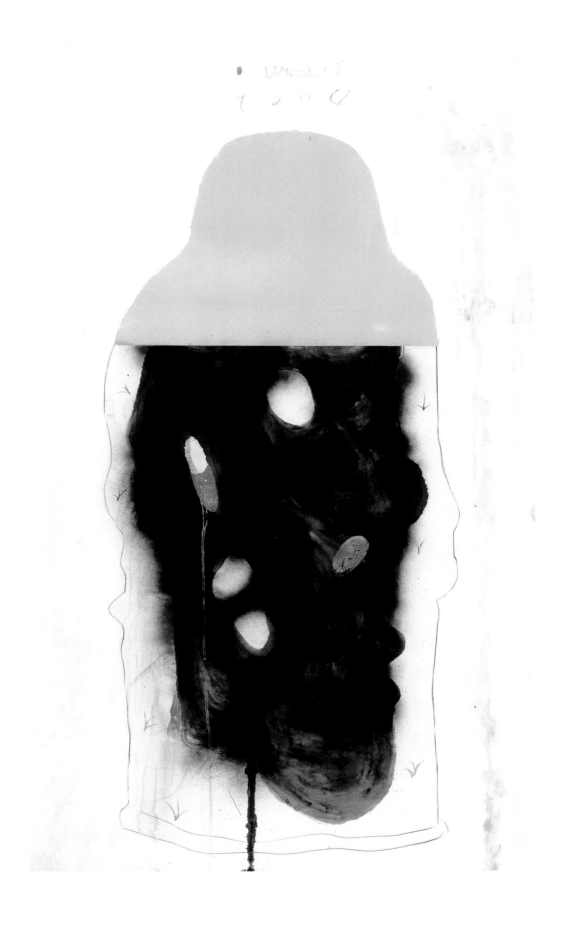

异化的风景－太湖石4号
宣纸　水墨综合材料
Unusual Scene No.4
Ink and Mixed Media
on Rice Paper
206 x 125 cm
2004

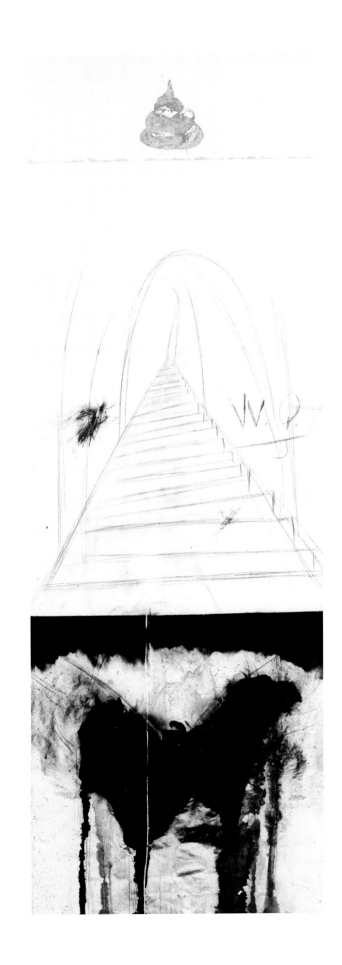

意义的类别No.1-2
宣纸　水墨综合材料
Sort of Meaning No.1-2
Ink and Mixed Media on
Rice Paper
207 x 69 cm
2005

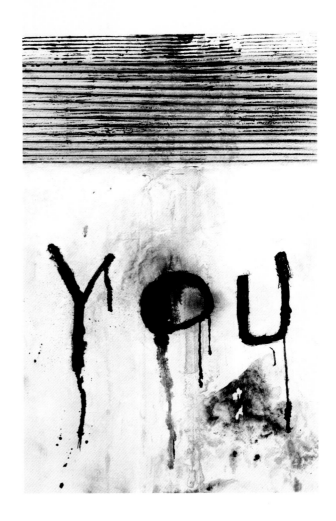

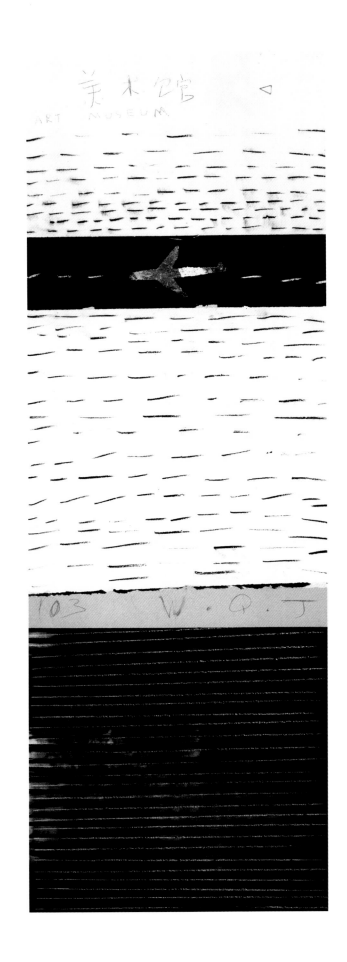

意义的类别 No.3—5
宣纸　水墨综合材料
Sort of Meaning No.3—5
Ink and Mixed Media on
Rice Paper
207 x 69 cm
2005

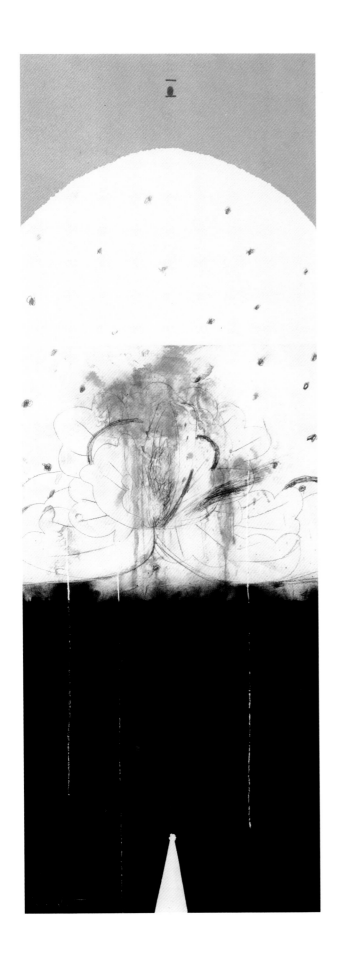
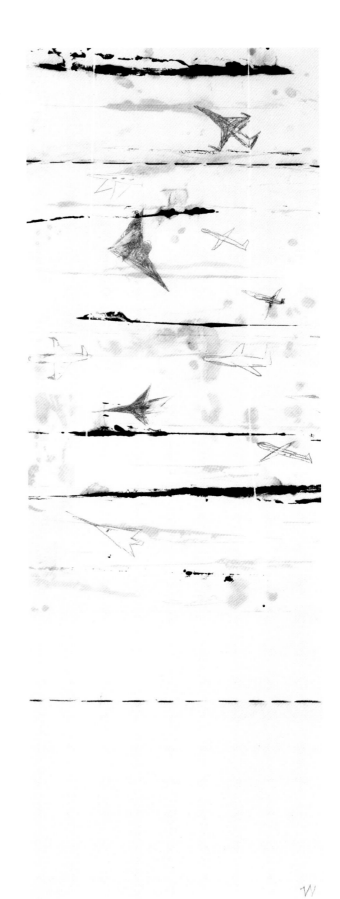

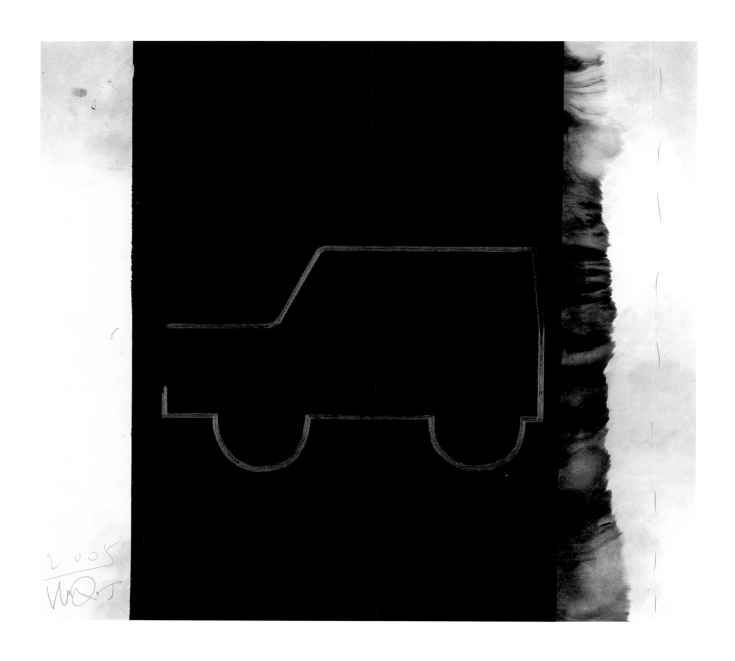

物－像 B—01
宣纸 水墨 茶 铅笔
Thing—Form B—01
Ink，Tea and Pencil on Rice Paper
90 x 95 cm
2005

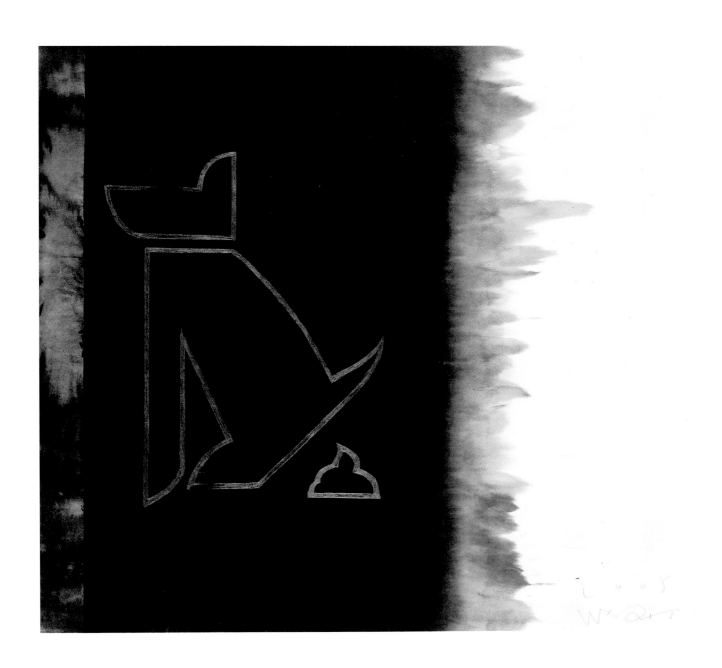

物－像 B—02
宣纸　水墨　铅笔
Thing—Form B—02
Ink and Pencil on Rice Paper
90 x 95 cm
2005

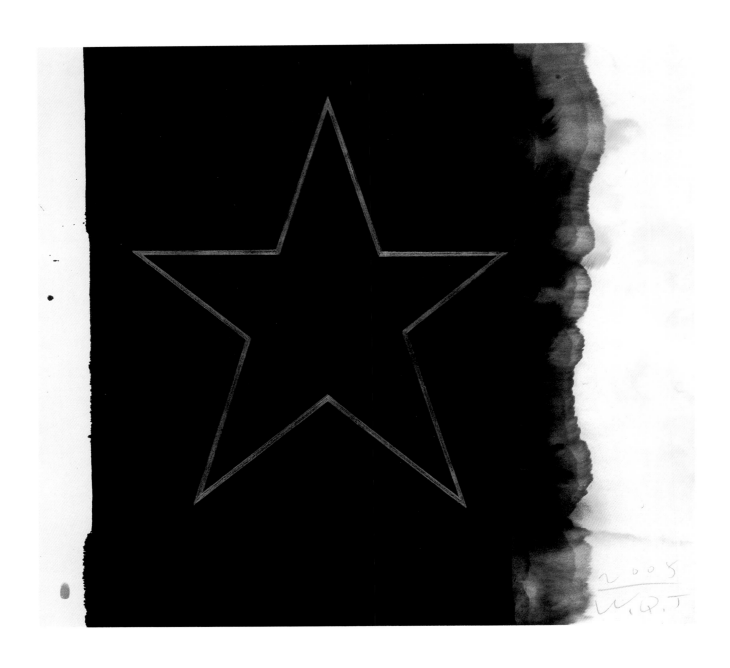

物－像 B—03
宣纸　水墨　茶　铅笔
Thing—Form　B—03
Ink Tea and Pencil on Rice Paper
90 x 95 cm
2005

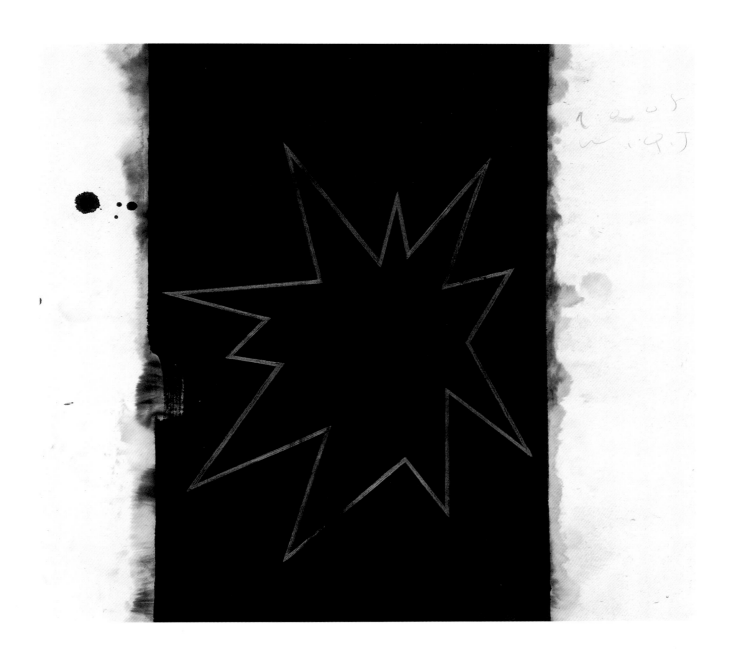

物－像 B—04
宣纸　水墨　铅笔
Thing—Form　B—04
Ink and Pencil on Rice Paper
90 x 95 cm
2005

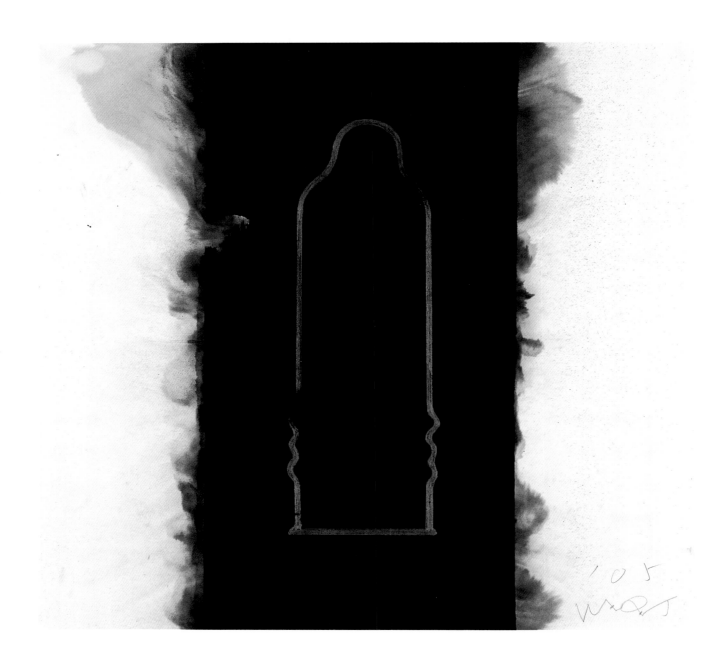

物－像 B—05
宣纸 水墨 铅笔
Thing—Form B—05
Ink and Pencil on Rice Paper
90 x 95 cm
2005

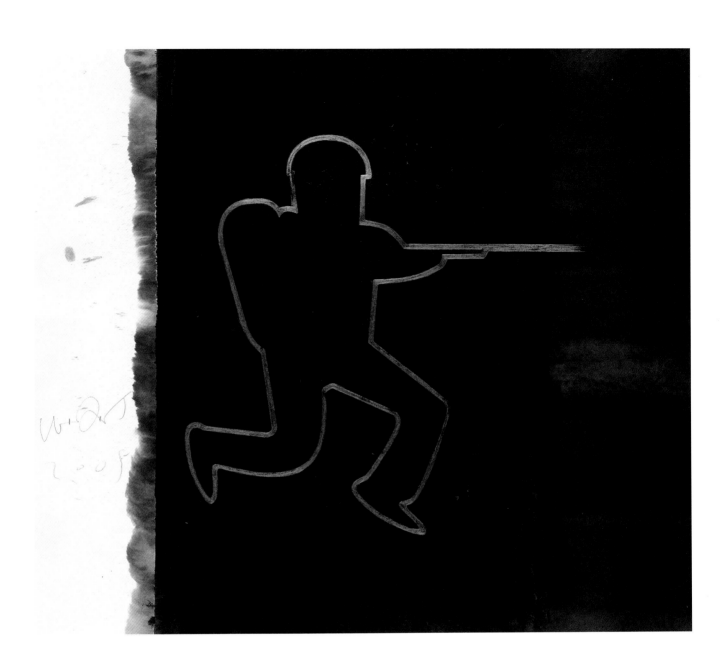

物－像 B—06
宣纸 水墨 茶 铅笔
Thing—Form B—06
Ink, Tea and Pencil on Rice Paper
90 x 95 cm
2005

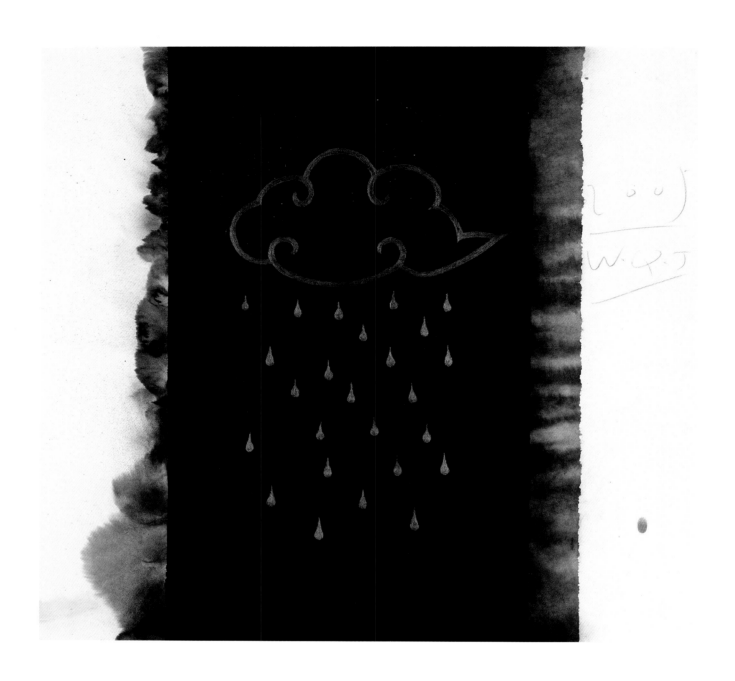

物－像 B-07
宣纸 水墨 茶 铅笔
Thing—Form B—07
Ink , Tea and Pencil on Rice Paper
90 x 95 cm
2005

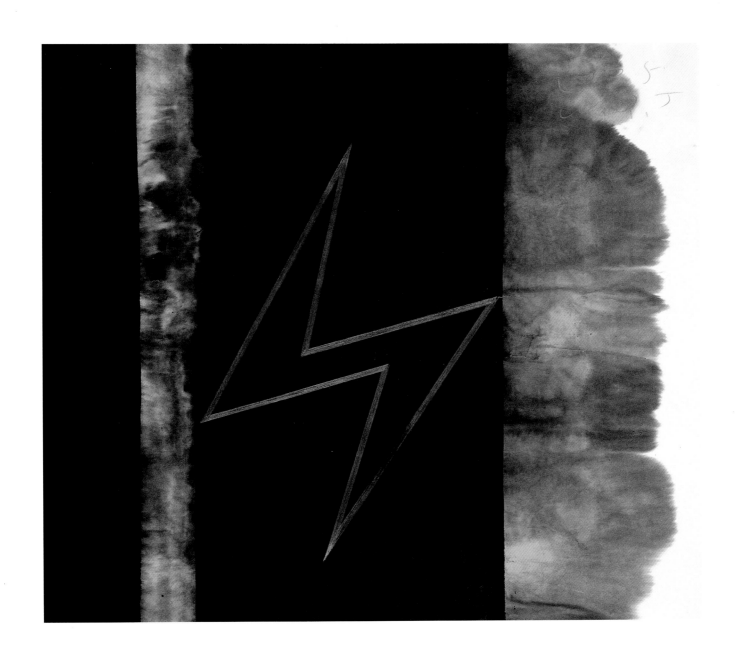

物－像 B—08
宣纸　水墨 铅笔
Thing—Form　B—08
Ink and Pencil on Rice Paper
90 x 95 cm
2005

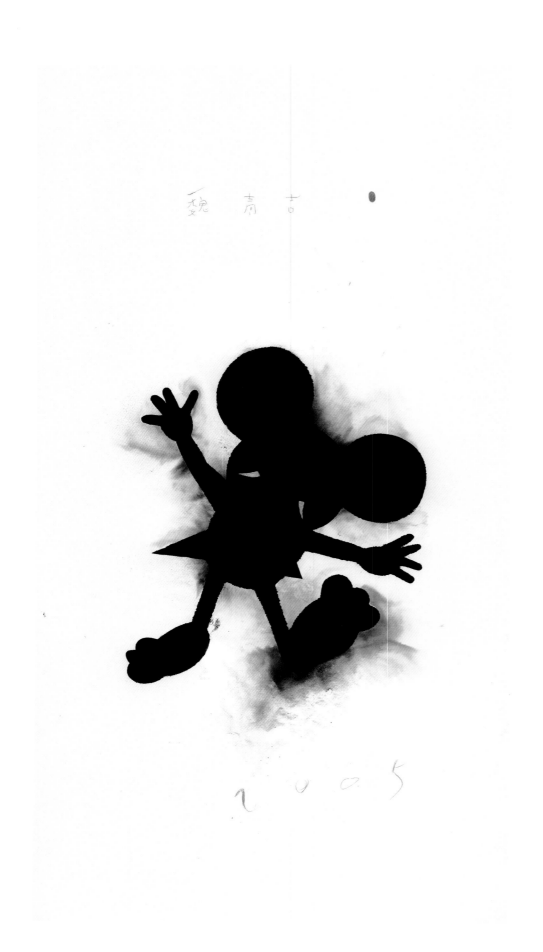

物－像 0501
宣纸　水墨综合
Thing－Form　0501
Ink and Mixed Media
on Rice Paper
185 x 95 cm
2005

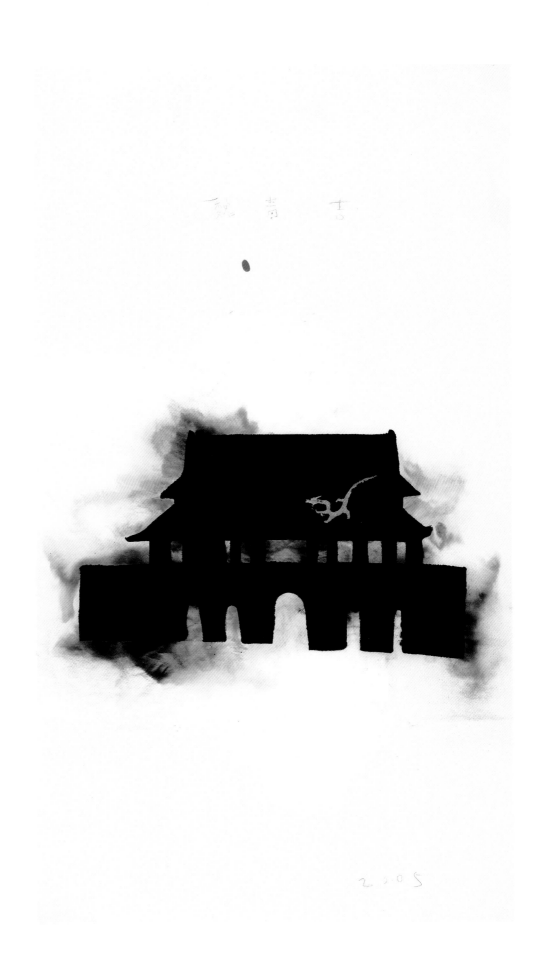

物－像0502
宣纸　水墨综合
Thing—Form　0502
Ink and Mixed Media
on Rice Paper
185 x 95 cm
2005

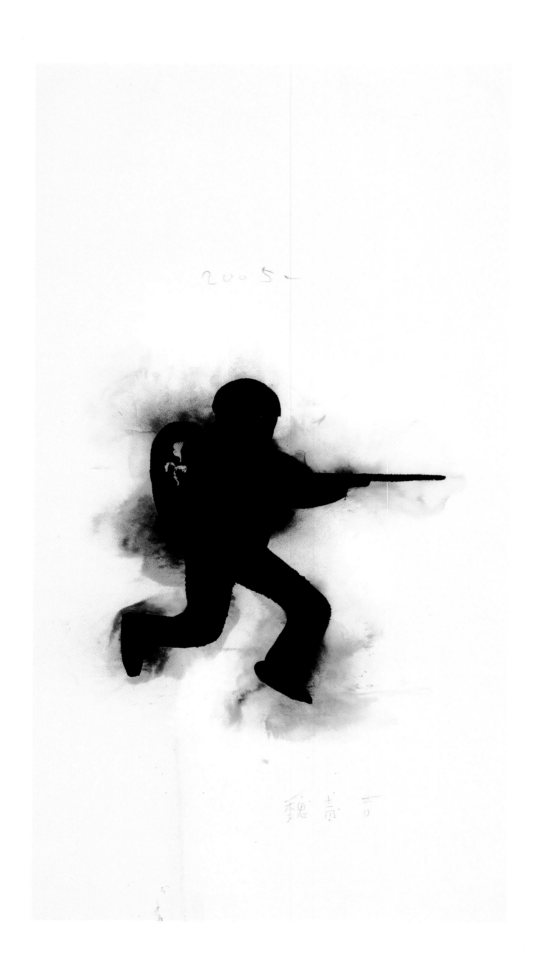

物－像 0503
宣纸　水墨综合
Thing—Form　0503
Ink and Mix Media
on Rice Paper
185 x 95 cm
2005

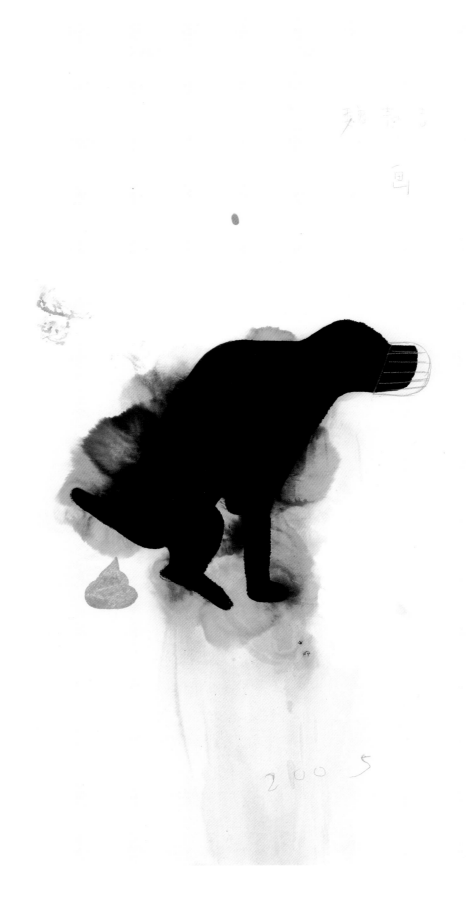

物－像 0504
宣纸　水墨综合
Thing－Form 0504
Ink and Mixed Media
on Rice Paper
185 x 95 cm
2005

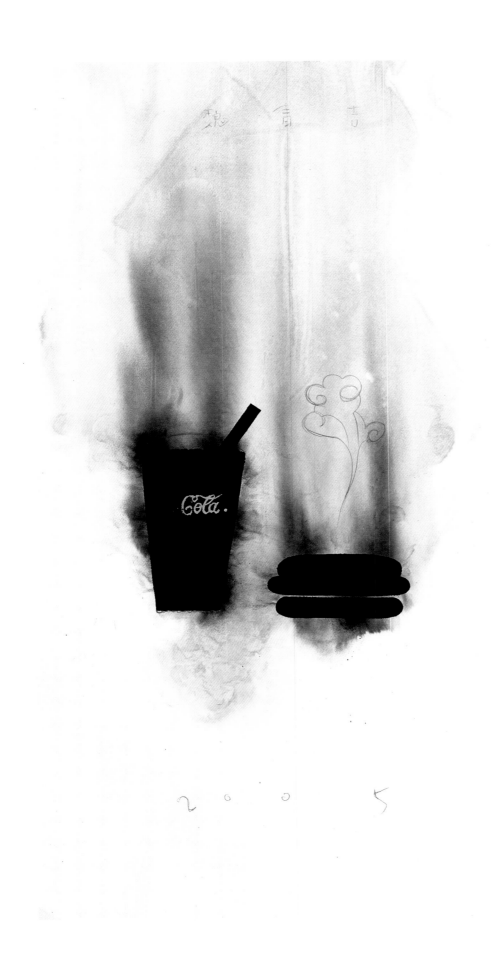

物－像0505
宣纸　水墨综合
Thing—Form　0505
Ink and Mixed Media
on Rice Paper
185 x 95 cm
2005

物－像 0506
宣纸　水墨综合
Thing—Form　0506
Ink and Mixed Media
on Rice Paper
185 x 95 cm
2005

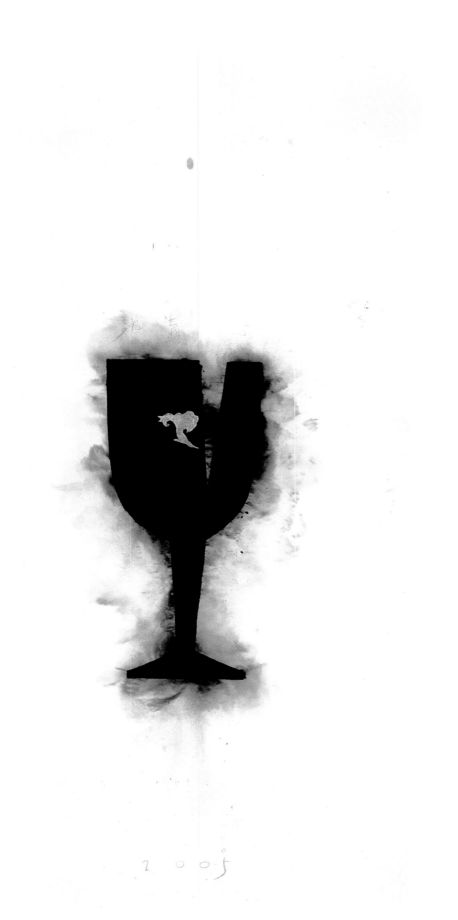

物－像0507
宣纸　水墨综合
Thing—Form　0507
Ink and Mixed Media
on Rice Paper
185 x 95 cm
2005

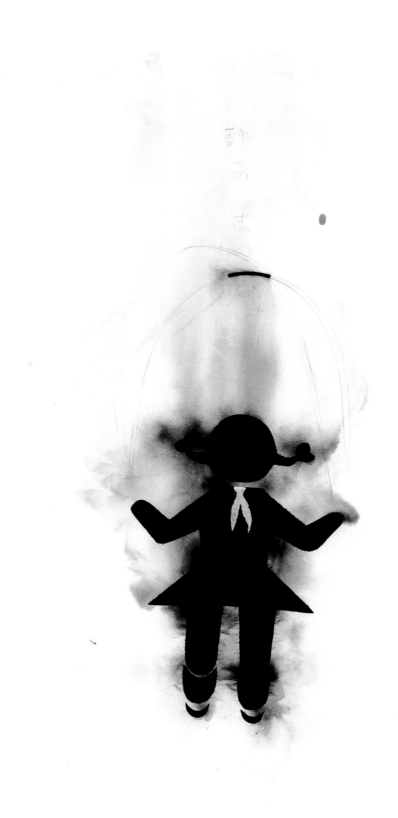

物－像 0508
宣纸　水墨综合
Thing—Form　0508
Ink and Mixed Media
on Rice Paper
185 x 95 cm
2005

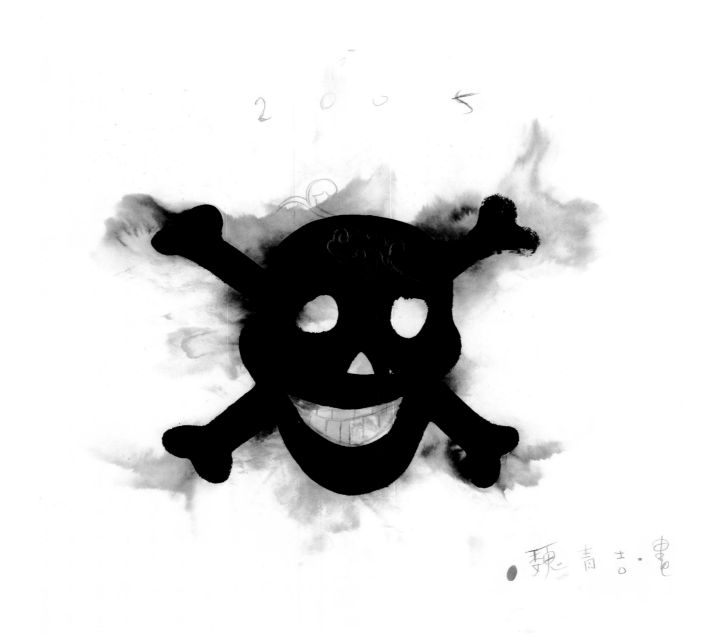

物－像 0509
宣纸　水墨综合
Thing—Form　0509
Ink and Mixed Media
on Rice Paper
90 x 95 cm
2005

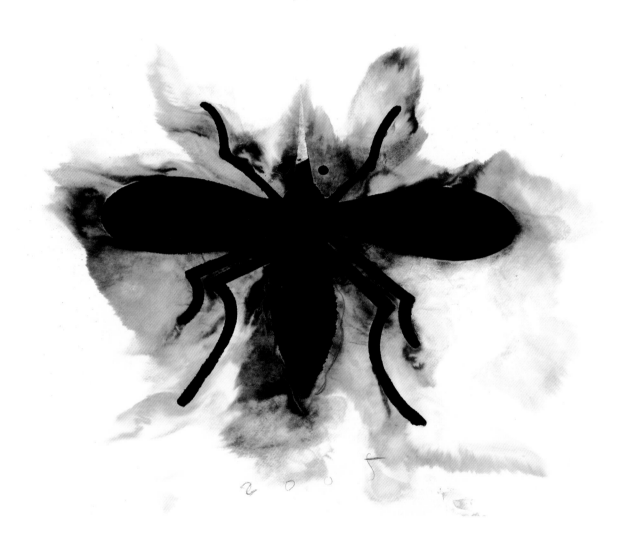

物－像 0510
宣纸　水墨综合
Thing—Form　0510
Ink and Mixed Media
on Rice Paper
90 x 95 cm
2005

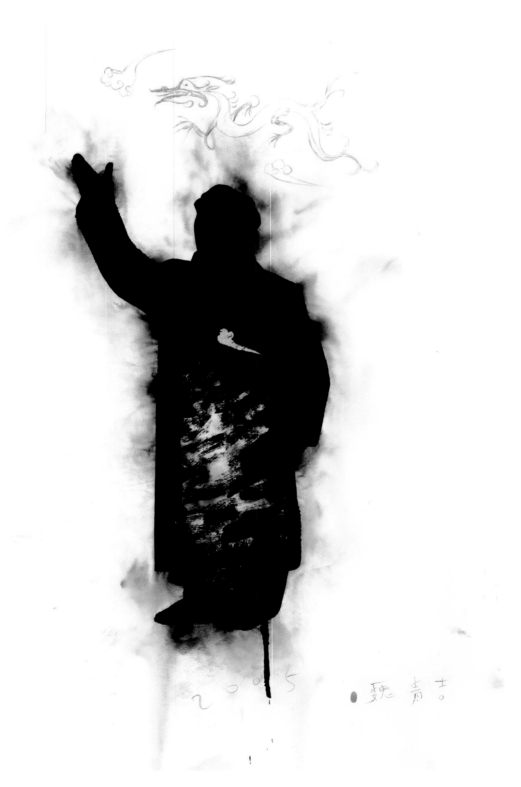

物-像 0511
宣纸　水墨综合
Thing—Form　0511
Ink and Mixed Media
on Rice Paper
165 x 125 cm
2005

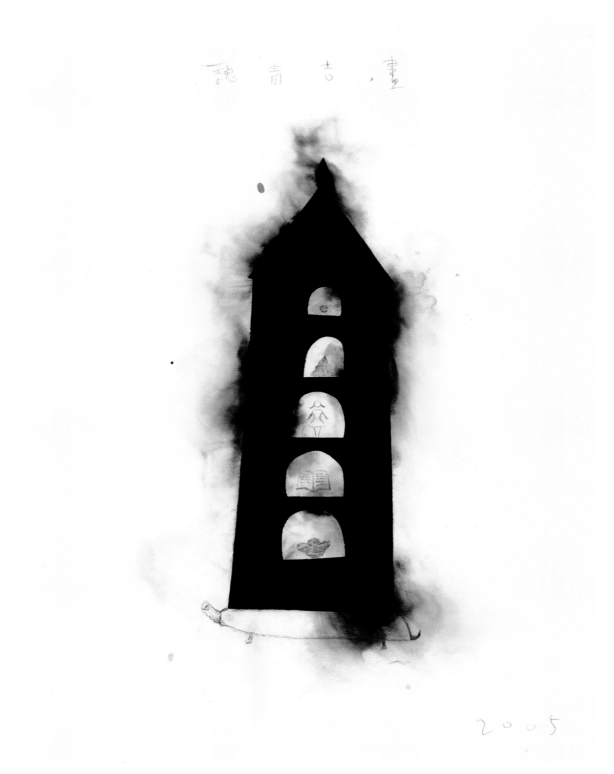

物－像 0512
宣纸　水墨综合
Thing—Form　0512
Ink and Mixed Media
on Rice Paper
165 x 125 cm
2005

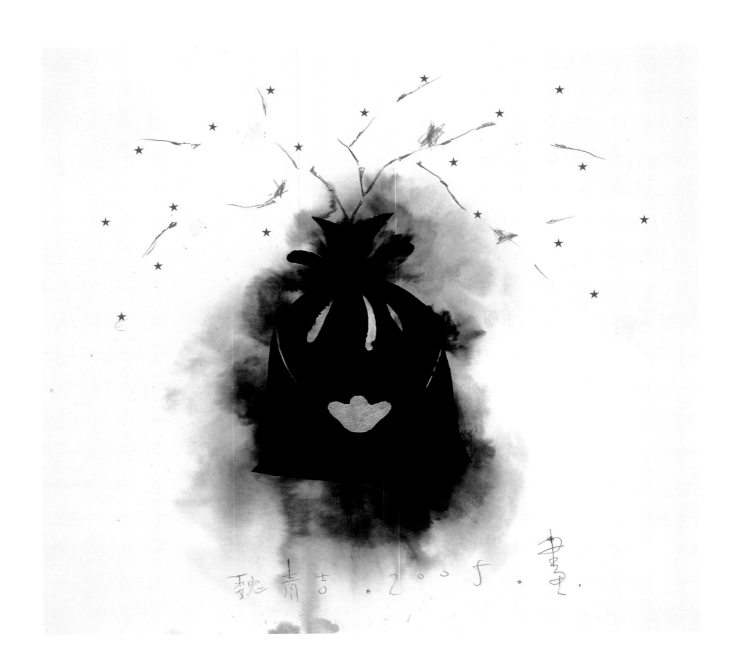

物－像 0513
宣纸　水墨综合
Thing—Form　0513
Ink and Mixed Media
on Rice Paper
90 x 95 cm
2005

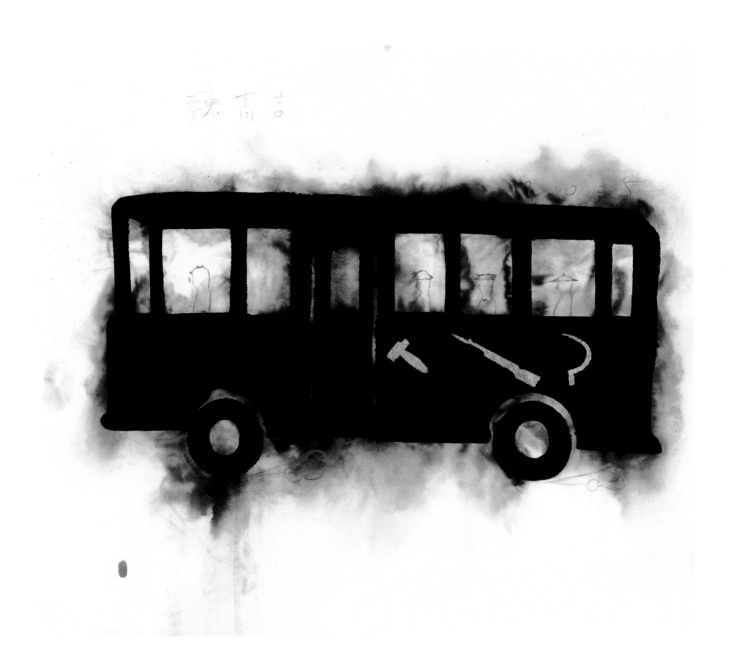

物－像 0514
宣纸 水墨综合
Thing—Form 0514
Ink and Mixed Media
on Rice Paper
90 x 95 cm
2005

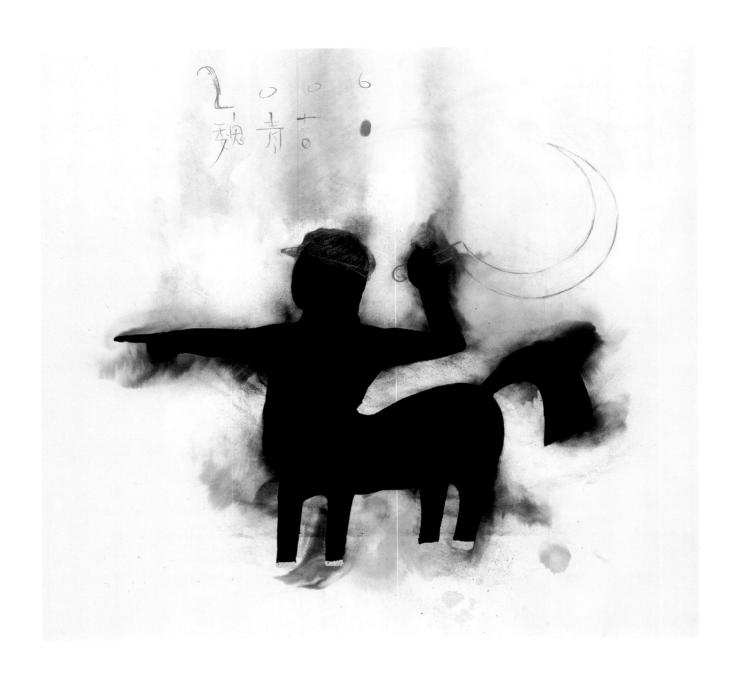

物－像 0601
宣纸　水墨综合
Thing—Form　0601
Ink and Mixed Media
on Rice Paper
90 x 95 cm
2006

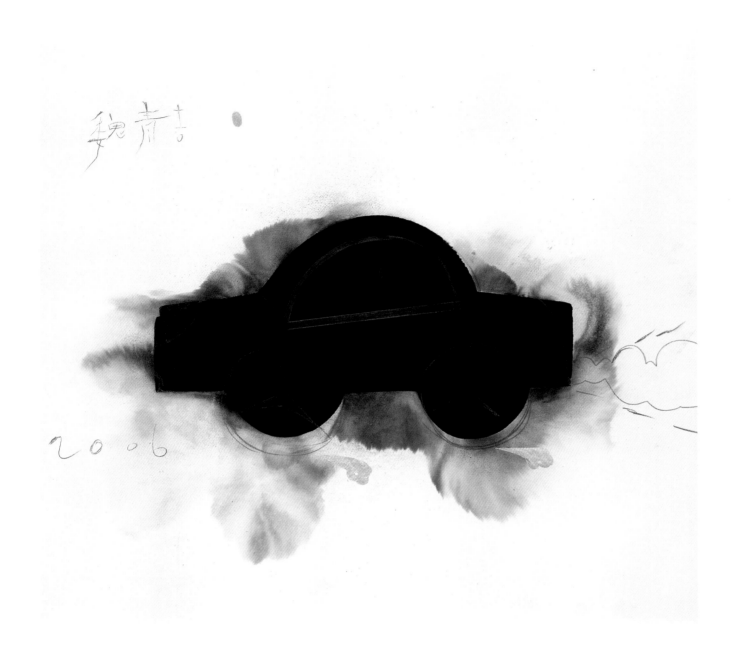

物－像 0603
宣纸　水墨综合
Thing—Form　0603
Ink and Mixed Media
on Rice Paper
90 x 95 cm
2006

物－像 0604
宣纸　水墨综合
Thing—Form　0604
Ink and Mixed Media
on Rice Paper
185 x 95 cm
2006

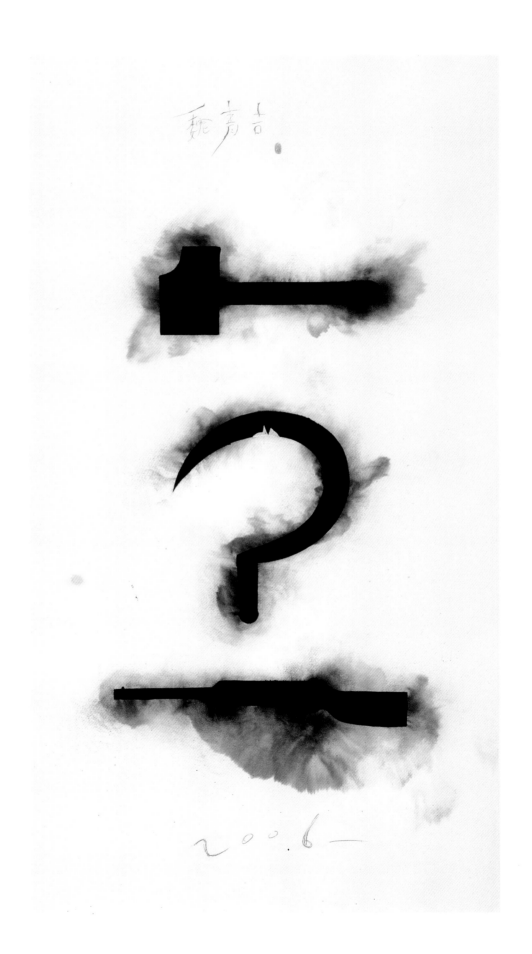

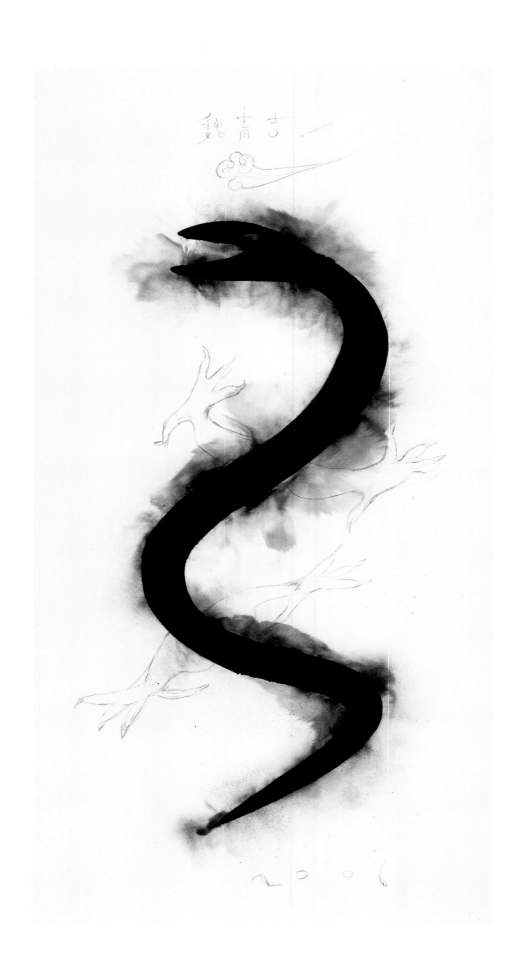

物－像 0605
宣纸　水墨综合
Thing—Form　0605
lnk and Mixed Media
on Rice Paper
180 x 95 cm
2006

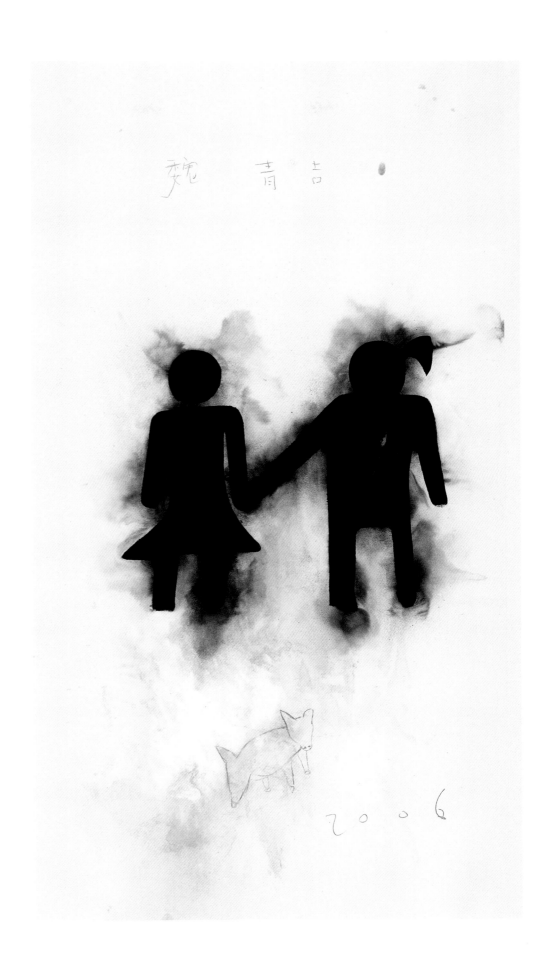

物－像 0606
宣纸　水墨综合
Thing—Form　0606
Ink and Mixed Media
on Rice Paper
180 x 95 cm
2006

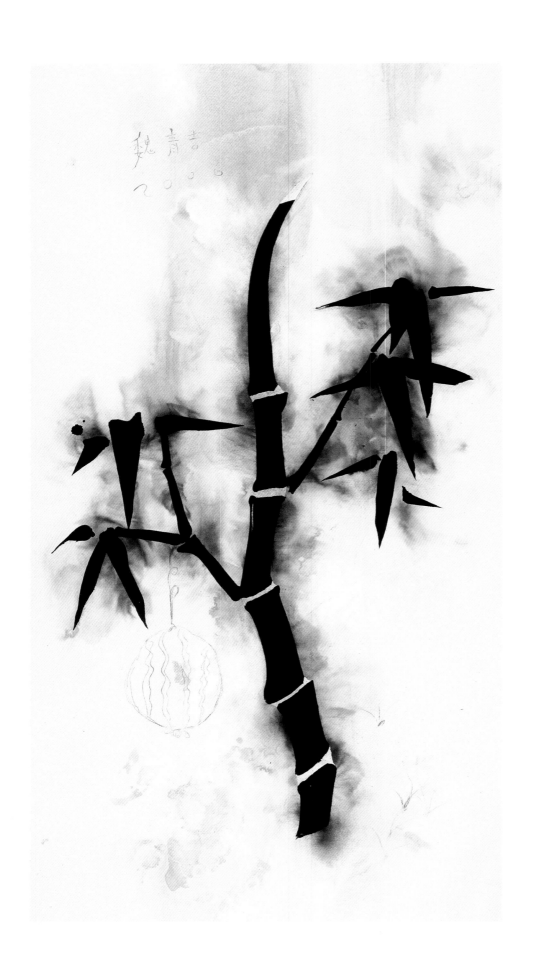

物－像 0607
宣纸　水墨综合
Thing—Form　0607
Ink and Mixed Media
on Rice Paper
180 x 95 cm
2006

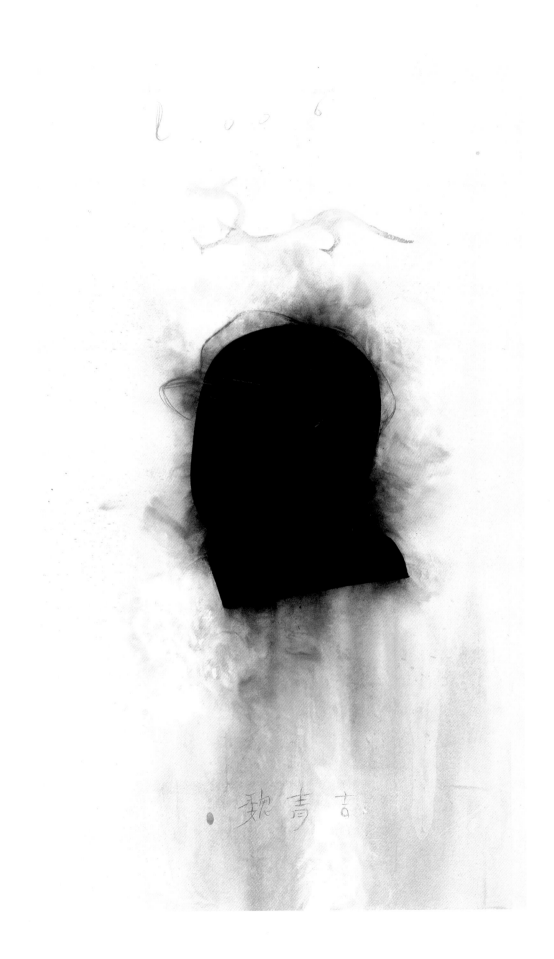

物－像 0608
宣纸　水墨综合
Thing—Form　0608
Ink and Mixed Media
on Rice Paper
180 x 95 cm
2006

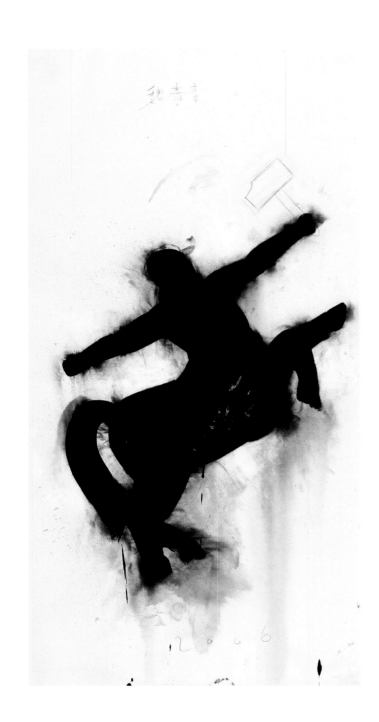

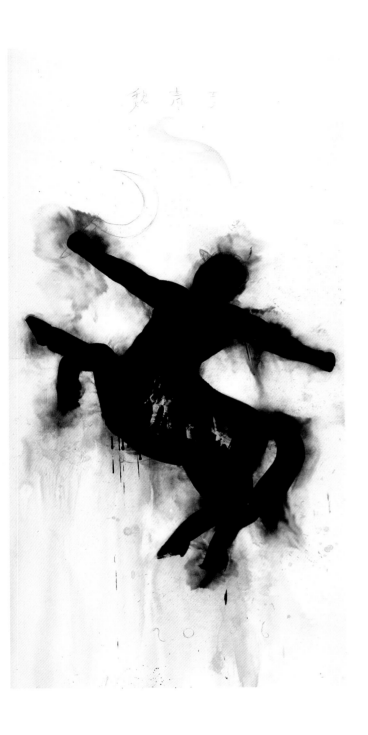

物－像 2006
宣纸　水墨综合
Thing—Form 2006
Ink and Mixed Media
on Rice Paper
245 x 125 cm x 3
2006

关于创作的自述

魏青吉

在近来的工作中，我致力于从绘画的本原出发，从那里展开并演绎个性的话语，并试图建立一套新的水墨表述语言，使绘画的装饰性、寓意性、叙事性得到新的意义上发挥；使水墨成为一种真正开放性的语言，真正适合观念多样性的表达而适应当下文化的挑战。同时，我也致力寻找一种差异性——因为今天应该是个性与多元化的时代。

"水墨"并非我身份的标签，也非文化权利斗争的工具，而是我观念表达的自觉选择——我喜欢也善于利用这一媒材，其极强的可塑性预示着在绘画语言表述上的无限可能。

通过水墨这一媒材，我所表达的是其中的物质和精神。同时，我赋予作品一种新的人文精神，画面成为我各种经验和感觉、思维和记忆出没无常的开阔场所。在具有"悬念"与"泛宗教化"的情境中，蕴含的或许是新的想象、个人激情、潜意识、历史的印记、宗教的神秘，当然，也不乏性感与诱惑。

对于我的作品而言，基本上是与记忆或日常生活有关。我热衷于探讨传统与当代的关系，确切的说在我们今天的生活中还有多少是我们自身所一直具有的，它们是以何种状态呈现着。我对历史文脉有着极大的兴趣，传统作为一种精神流动体可以使我们记忆连贯，同时传统在保障文化的生命力方面也是不可缺少的，在保证人类在常变常新的同时，仍具某种我们可以辩认的东西。当然我们不可能回到以前，也不能以和过去同样的方式进行表达，我致力于让传统的媒材发出新的声音，无论是图像还是观念都应该与自身的和日常的经验有关。

我所关心的是传统与今天的关系本身——尽管是含糊与暧昧的，但正是其魅力之所在，至于这种关系是衔接还是背离？那已并不重要。我尽量只提示而不阐释，作中性表达，避免使自己的叙述落入到一种新的"话语权力"之中。我所坚持的这样一种绘画的方式实际上也就是我现阶段的文化立场——不以更快为目标，不以更新为标准。

A SELF-ACCOUNTING OF ARTISTIC CREATION

Wei Qingji

In recent works, I have been committing myself to developing an individualistic discourse in, and from, the fountainhead of painting. I am attempting to establish a new set of language for *ink and wash painting* expression, thus bringing the ornamentality, allegoricity, and narrativity of the painting into new play, and making the *ink and wash painting* a genuinely open language, which, can be truly adapted with pluralistic expressions, to meet the challenges of the current culture. Meanwhile I am bent to seek a kind of otherness - for the present age is one of individuality and pluralism.

"*Ink and wash painting*" is neither a label of my identity nor a tool for striving for cultural rights. Instead, it is a conscious choice for the expression of my own ideas - I am fond of and good at employing such a media, as its extreme plasticity implies an infinite possibility of the linguistic expression of the painting.

Through the media, *ink and water*, what I seek to express is the material and the spirit in it. At the same time, I tend to endow my works with a new humanistic spirit. The drawings have become an open space, haunted by all sorts of my experiences, feelings, thinking, and memories. What is implicated in the suspenseful, pan-religious situations are perhaps new imaginations, personal passions, sub consciousness, historical marks, religious mystery, and of course, sexuality and temptation.

Most of my paintings are concerned with memory, or everyday life. I'm interested in exploring the relation between the traditional and the contemporary, or to be exact, in finding out what has remained in today's life that have been always with us, and in what forms they exist in us. I have a great interest in the historical unity and continuity, for I believe that our tradition, as a spiritual flux, can keep our memories coherent and is thus indispensable to the maintenance of the vitality of our culture, and that it can remain to be something recognizable, while at the same time ensuring the constant transformation of our culture. To be sure, we can never return to the past, nor can we express ourselves in the same way as before. I am dedicated to making traditional media utter new voices, and making both images and ideas related to our everyday experiences.

What I am most concerned about is the relation between the traditional and the contemporary, though it may be vague and ambiguous. However, the very vagueness and ambiguity are exactly where its charm lies. It is of trivial significance whether this relation is a kind of connection, or a sort of betrayal. Instead of elucidating explicitly, I am just trying to suggest and make a neutral expression, so that my narration would not fall into a new kind of discursive hegemony. The way of painting, that I have been sticking to, is in fact my current cultural standpoint: that is, not aiming at being faster and newer.

魏青吉 , 1971 年生于山东青岛

1995 年至今, 任教于广州华南师范大学美术学院
2003 年, 毕业于中央美术学院壁画系研究生班
1995 年, 毕业于南开大学东方艺术系中国画专业, 获学士学位

个展:
2006　物·像 2005－2006　*法国艾克斯马赛第三大学*
　　　　记忆的属性　*高地画廊, 北京*

联展:
2006　中国水墨文献展　*南京博物院*
　　　　中国当代艺术年鉴展　*中华世纪坛艺术馆*
　　　　冥想与叙事－当代水墨艺术展　*香港艺术公社*
　　　　第三届中国国际画廊博览会　*北京中国国际贸易中心*
　　　　国际现代水墨艺术展　*美国纽约亚洲文化艺术中心*
　　　　上海新水墨艺术大展　*上海朱屺瞻美术馆*
　　　　有一点神秘 II　*法国马赛－艾克斯*
　　　　渡·当代水墨方式　*天津美术学院美术馆*
2005　大名大方　*香港万玉堂画廊*
　　　　现代水墨艺术大展　*台湾巡回展*
　　　　纸和墨: 中国当代艺术展　*德国魏玛美术馆*
　　　　质性－实验水墨报告　*北京红门画廊*
　　　　第二届成都双年展　*成都国际展览中心*
　　　　实验水墨回顾展 1985－2000　*深圳画院*
　　　　中国上墨－实验水墨展　*法国里尔瑞月宫*
　　　　中韩当代水墨画展　*韩国汉城市立美术馆*
　　　　金陵水墨传媒展　*江苏国画院美术馆*
　　　　翻手为云, 覆手为雨　*北京 TS1 当代艺术中心*
　　　　第二届广州当代艺术三年展　*广州信义会馆*
2004　点, 辐射与深入　*马来西亚国家美术馆*
　　　　广东新青年艺术大展　*广东美术馆*
　　　　永远的民主　*美国纽约 Plum Blossoms 画廊*
　　　　第十九届亚洲国际艺术展　*日本福冈亚洲美术馆*
　　　　南京水墨传媒三年展　*江苏美术馆*
2003　印象中国　*法国巴黎印象画廊*
　　　　"向前进"－来自中国的当代艺术　*新加坡国立大学博物馆*
　　　　中国实验水墨展　*北京红门画廊*
　　　　无常　*香港艺术公社*
　　　　中国制造　*法国 Daniel & Florence Guerlain 艺术基金会*
　　　　今日中国美术大展　*北京中华世纪坛美术馆*
　　　　虚幻－当代艺术巡回展　*香港 M63、广东美术馆*
2002　中国当代水墨名家邀请展　*河北画院*

简 历 RESUME

水墨新纪元　台北国父纪念馆，观想艺术中心
现象："后岭南"与广东新水墨　广东美术馆
"桥" – 长春当代艺术年度展　长春远东美术馆
中国当代陶瓷艺术大展　佛山石敬宜美术馆
第一届广州当代艺术三年展　广东美术馆
第四届上海双年展　上海美术馆
2001　城市俚语 – 珠江三角洲的当代艺术　深圳何香凝美术馆
人类景色　北京艺术文件仓库
重新洗牌　深圳雕塑院
水墨实验二十年　广东美术馆
冲突与包容 – 中国当代艺术展　意大利曼托瓦青年博物馆
第一届成都双年展　成都现代艺术馆
杜塞尔多夫国际艺术大展　德国杜塞尔多夫展览中心
第十六届亚洲国际艺术展　广东美术馆
西安国际抽象水墨邀请展　西安国际展览中心
2000　新中国画大展　上海刘海粟美术馆
在水墨的边缘　香港艺术发展局视艺空间、环境艺术馆
墨、墨、墨……　上海朱屺瞻艺术馆
1999　水墨与装置互动展　香港艺术公社
复数·个性　广州华南师范大学美术馆
后生代与新世纪　广东美术馆
1997　中国艺术大展　上海美术馆
三面展　广州华南师范大学美术馆
1993　第二届当代山水画展　武汉长江艺术家美术馆

作品公共收藏：
意大利曼托瓦青年博物馆
法国 Daniel ＆ Florence Guerlain 当代艺术基金会
法国 Conseil Général des Yvelines
新加坡国立大学博物馆
日本东京 Zeit–Foto Salon
香港艺术馆
香港环境艺术馆
广东美术馆
世界华人艺术出版社
陈弋艺术基金会
南开大学
南京大学

作品出版：
《今日中国美术丛书 – 魏青吉》国际文化出版社，2002 年
《黑白史 – 中国当代实验水墨 1992－1999·魏青吉》湖北美术出版社，1999 年

Wei Qingji was born in Qingdao, Shandong in 1971

1995- now, teaches in the College of Art in South China Normal University in Guangzhou
2003, gratuated from Mural Department of the Central Academy of Fine Arts , as a Postgraduate.
1995, gratuated from Oriental Art Department of Nankai University and earned his bachelor's degree.

Solo Exhibitions:

2006 *Thing-Form 2005-2006*, Marseille III University, France
 The Property of Memory, High Land Gallery, Beijing, China

Group Exhibitions:

2006 *The Exhibition of Chinese Painting Documentaries*, Museum of Nanjing, Nanjing, China
 1st Annals Exhibition of Chinese Contemporary Art, Millennium Art Museum, Beijing, China
 China International Gallery Exposition 2006, Exhibition Hall of China World Trade Center,
 Beijing, China
 Meditation and Narration-Contemporary Ink Exhibition, Artist Commune, Hong Kong
 International Modern Chinese Ink Painting Exhibition, Asian Cultural Center, New York, U.S.A
 Shanghai New Ink Painting Exhibition, Zhu Qizhan Museum of Art, Shanghai, China
 Un Peu D'Alice II, Marseille/Aix, France
 Expressions of Contemporary Chinese Ink and Wash , Gallery of Tianjin Academy of Fine
 Arts, Tianjin, China
2005 *Blossoming*,Plum Blossoms Gallery,Hong Kong
 Exhibition of Modern Ink and Wash, Circuit in Taiwan,China
 Ink and Paper-Exhibition of Contemporary Chinese Art, Kunsthalle Weimar, Germany
 The Quality of Materiality: Experimental Ink and Wash, Red Gate Gallery, Beijing, China
 2nd Chengdu Biennale, International Center of Exhibition, Chengdu, China
 Retrospection of Experimental Ink & Wash 1985-2000, Shenzhen Fine Art Institute,
 Shenzhen, China
 Exhibition of Contemporary Ink and Wash Painting, Art Museum of Seoul, Korea
 Exhibition of Jinling Ink and Wash Media, Gallery of Jiangsu Chinese Painting Institute
 The Second Guangzhou Triennial, Xin Yi International Club, Guangzhou, China
 Opening Exhibition of TS1 Contemporary Art Center, TS1 Contemporary Art Center,
 Beijing,China
 Ink on Paper-Contemporary Ink and wash, Palace Rihour, Lille, French
2004 *Dot, Proliferation and Penetration*, National Gallery, Malaysia
 Open Attitude, Guangdong Museum of Art, Guangzhou, China
 The 19th Asian International Art Exhibition, Fukuoka Museum of Asia Art, Japan
 Democracy Forever, Plum Blossoms Gallery, New York, U.S.A
 Ink and Wash Media Triennial of Nanjing, Jiangsu Museum of Art, Nanjing, China
2003 *Impression China*, Impression Gallery, Paris, France
 Moving On - Contemporary Art from China, NUS Museum, Singapore
 Uncertainty, Artist Commune, Hong Kong, China
 Chinese Experimental Ink and Wash Exhibition, Red Gate Gallery, Beijing, China
 Made in China, Daniel and Florence Guerlain Contemporary Art Foundation, France
 Chinese Art Today, Millennium Art Museum, Beijing, China
 Illusion, Museum63, Hang Kong: Guangdong Museum of Art, Guangzhou, China
2002 *Chinese Contemporary Ink and Wash*, Hebei painting Institute, Shijiazhuang, China